CARTOONING, CARICATURE AND ANIMATION
Made Easy

Chuck Thorndike

DOVER PUBLICATIONS, INC.
Mineola, New York

Bibliographical Note

This Dover edition, first published in 2003, is a compilation of the two works originally published by The House of Little Books, New York, under the titles *The Secrets of Cartooning: An Instruction Book on Humorous Drawing* and *The Art of Cartooning: An Advanced Instruction Book on Humorous Drawing* in 1936 and 1937, respectively. The text has been reset for this edition.

Library of Congress Cataloging-in-Publication Data

Thorndike, Chuck, b. 1897.
 [Secrets of cartooning]
 Cartooning, caricature, and animation made easy / Chuck Thorndike.
 p. cm.
 Consists of two works. First work originally published: Secrets of cartooning. New York : House of Little Books, c1936. 2nd work originally published: Art of cartooning. New York : House of Little Books, c1937.
 ISBN 0-486-43152-5 (pbk.)
 1. Cartooning—Technique. I. Thorndike, Chuck, b. 1897. Art of cartooning. II. Title.

NC1764.T485 2003
741.5—dc22

2003055768

Manufactured in the United States of America
Dover Publications, Inc., 31 East 2nd Street, Mineola, N.Y. 11501

CONTENTS

THE SECRETS OF CARTOONING

THE AUTHOR

The author of this little book has been drawing cartoons for over twenty-five years. Starting out as a contributor to high school publications, he then worked in a Seattle engraving shop, next on the San Francisco Bulletin, then drawing animated (movie) cartoons, and later in the Marine Corps he contributed to the "Leatherneck." After the war, during three years of art school, he contributed to college publications. Then followed a trip to New York where he has served as art director for several advertising agencies and national magazines. He is connected with several newspaper syndicates, and contributes to the *Saturday Evening Post, Life, Judge, College Humor, Ballyhoo, Hooey,* and other magazines, including several foreign publications.

FOREWORD

This book is published as a much-needed and compact method of instruction for the ambitious art student and cartoonist.

Based primarily upon the experience of teaching hundreds of cartoon students throughout the country, its purpose is to fulfill most of their needs and answer their questions.

It is a fact, opinions to the contrary notwithstanding, that an accomplished cartoonist is, to a very large extent, his own boss. The amount of his success depends almost entirely upon his own talents, his ability to concentrate on his work, the confidence that the people he is working for hold in him — but probably most of all, the amount of satisfaction he or she gets out of doing a good job.

It is the hope of the author that the reader gets as much pleasure and benefit out of this book as he has had in preparing it.

MATERIALS

It is obviously impossible to list all of the necessary materials here, but here are the items which are really fundamental necessities. Please remember that "a workman is only as good as his tools" — so the better the materials, the better the job. Note: See p. 58 for materials for advanced techniques.

WORK BENCH

DRAWING TABLE — A good-sized, adjustable-top table, about 40 inches by 30, is the handiest to use. However, if you can't get this, use a thin-veneered drawing board (which won't warp) on a table. Get a 75 or 100 watt BLUE GLOBE and keep this light above you and to your LEFT. (if you're right-handed)

A TABOURET or stand should be at your right, with a shelf for your pencils, pens, brushes, colors, ink, water jar, etc. It should also contain drawers in which you keep some of your reference clippings.

PAPER

Use cold-pressed paper or BOARD, about 3-ply, for wash drawings. Hot-pressed or smooth-surfaced paper, whether kid or vellum, should be used for pen-and-ink work. Coquille paper or Ross board for sport or other drawings, requiring lithographic crayon. SCRATCH BOARD for working white lines on a black surface. (Thumb-tack your paper down when doing lettering and borders, using T-square and triangle — when sketching adjust the paper to suit your convenience.

PENCILS

Use a HARD pencil, #H or 3, about 5 inches long, with eraser attached, for lettering. Soft, 6B pencil, for sketching people, etc. Medium or #2 for preliminary drawing before inking in. Lithographic or "grease" pencil or crayon for gray-tone effects on sport drawings, etc. Blue pencil for indicating Ben-Day effects. White pencil for working on black paper.

PENS

Use a fine copper pen point for delicate line or "thick-and-thin" outline (adapt kind suitable to your touch). Use a small stiff or ball-pointed pen for small lettering (as in strips, etc.). A large round-pointed pen should be used for cartoon poster lettering or large "caps" in balloon talks, etc.

MECHANICAL INSTRUMENTS

A 5-inch ruling pen should be used for borders, etc. Have a 5-inch pen and pencil compass and a 3-inch pen compass handy. Also a 24-inch metal-edged ruler, an adjustable-head 24-inch metal-edged T-square, a 10-inch, 50-degree transparent triangle, a wooden pantograph (for enlarging pictures accurately and quickly).

BRUSHES

Get a large, red sable wash brush, several small #2 and #3 pointed camel's hair brushes for small line work and filling-in, and a couple of #11 pointed camel's hair brushes for "detail" wash work. (Use an old toothbrush for ink-spatter work. Rubber cement with paper stencil or cover with light glue that part of the drawing you don't want spattered, then remove stencil or wash off glue, after spatter is completed.)

LESSON ONE ... THE HEAD

The head is the most frequently used and also the simplest form in cartooning. Therefore, the student should learn these proportions thoroughly before proceeding further. Although there is nothing difficult about the chart on the opposite page, it is too often abused due to carelessness.

The most important points are the SHAPE of the head and the PLACING and perfect BALANCE of the features. Can you draw a nice looking oval or egg-shape without much trouble? This may seem simple but you will be wise to practice sketching this simple form. After the oval is drawn, the next step is to locate the placing of the eyes which are on a horizontal line halfway (usually) between the top of the head and the bottom of the chin. Then draw your perpendicular line down through the center of the oval, to give the face an even BALANCE. Note that the ears are placed between the eyebrows and the bottom of the nose. From the side or profile view, you will observe that the head is square but that the features remain in the same relative position as in the front view. These rules are only a general guide in the construction of a head drawing and vary, of course, according to the subject you are doing.

To overcome difficulties you may have in drawing the head, copy the shapes on this lesson's chart over and over again, until you have thoroughly mastered them — then draw them from memory. Make these heads from one-half inch to five inches in depth. When you do this correctly, it will develop that confidence of knowledge which is one of the first important steps in creative drawing.

LESSON NUMBER ONE
The HEAD

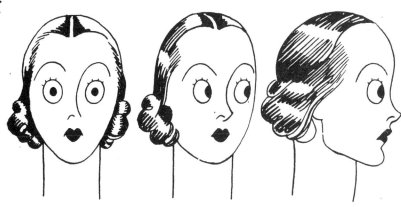

FEMALE HEAD SMALLER THAN MALE –
NOTE LARGER EYES AND HAIR TREATMENT.

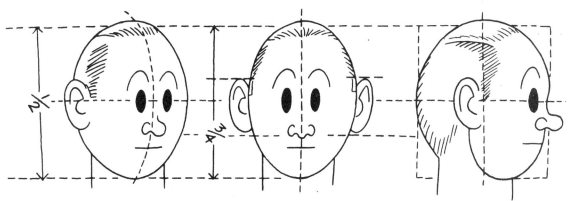

THREE-QUARTERS VIEW.
HEAD IS SLIGHTLY
WIDER THAN IN
CHART ON RIGHT.

FRONT VIEW.
NOTE EGG-SHAPED
HEAD AND EVENLY-
BALANCED FEATURES.

SIDE VIEW.
HEAD HERE IS ABOUT
SQUARE-BUT FEATURES
REMAIN IN SAME POSITION

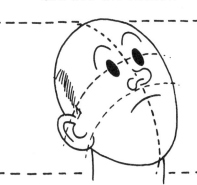

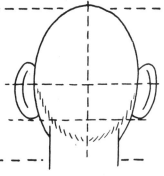

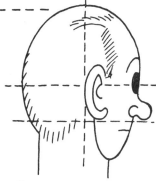

¾ FORESHORTENED.
NOTE RETENTION OF
EGG-SHAPE AND
CURVE OF GUIDE LINES.

BACK VIEW.
NOTE TOP OF
NECK AND POSITION
OF EARS.

THREE-QUARTERS BACK.
SAME WIDTH AS
THREE-QUARTERS FRONT
(NOTE EAR LOCATION)

CHUCK
THORNDIKE

LESSON TWO ... EXPRESSIONS

From the standpoint of putting "life" or "personality" into your cartoons the opposite plate on expressions and action is most important. There are times when the dumbest situation or gag can be saved by the expressions on the characters depicted. Try not to get meaningless lines in your faces but make every one contribute to the "type." Don't be afraid of careful exaggeration to emphasize a point but avoid careless distortion. Study the expressions on people's faces and either sketch them or try to memorize them. Public assemblies are one of the best places to do this, or you can draw your own face in the mirror.

Also study the expressions on characters you see in the movies and make mental notes of them. Be sure to make your expressions fit the situation — as there is a subtle difference, at times, between facetiousness or weirdness and a really humorous effect. One of your best opportunities to get originality in your drawings is in the expressions on your characters.

As in all other lessons, draw and re-draw the expressions on this plate until you can do them perfectly from memory. Note particularly the difference between such expressions as fear, horror and surprise, anger and disgust, etc.

Make a particular study of the expressions on the faces of the animals in animated cartoons and then adapt them to your particular style. By this I don't mean to "swipe" another artist's treatment as this will only reflect on your work.

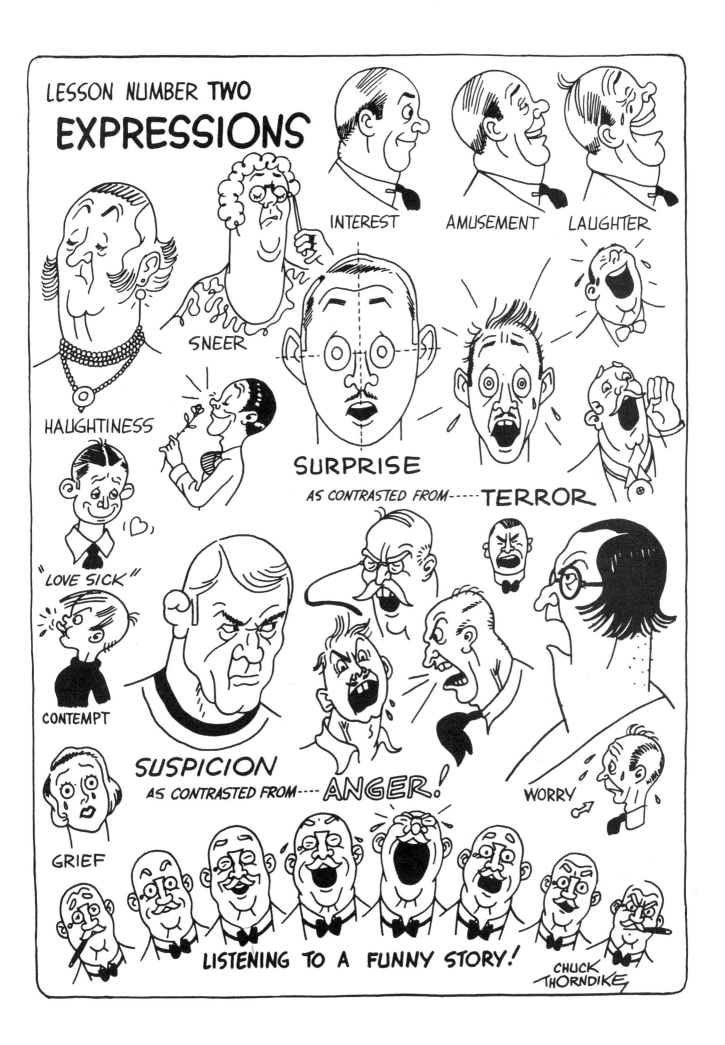

LESSON THREE ... ACTION

TO BECOME AN OUTSTANDING CARTOONIST, YOUR DRAWINGS
MUST EXPRESS ACTIONS IN A NATURAL AND CONVINCING WAY.

Try to give your sketches plenty of swing, but base them upon natural life. In other words, don't try to "imagine" your figure in too many impossible positions, but pose yourself in the natural position so that it will be more authentic. The main trouble with students' action drawings is that they either get too much foreshortening in them or draw them out of balance. FORESHORTENING means, of course, that certain parts of the body stand forward of other parts, such as a hand on an arm pointing almost directly at the reader or a figure that is diving through the air straight at you. In other words, three-dimentional drawing instead of two-dimensional. Foreshortening is the hardest part of an action drawing and the student should use the greatest care to see that his proportions are correct.

Here again, OBSERVATION is one of the best methods of procedure. Make your readers actually see themselves in your drawings and not some strange creature from another world. Sport drawings are, of course, tops in action study. Make as many quick sketches or notes as you can at fights, wrestling matches, track meets, etc. Then take them home and redraw them and you'll be surprised how much they help you.

Get a copy of a good anatomy book and study the bones and muscles of the body thoroughly. A thorough knowledge of anatomy is absolutely essential in sport or other forms of cartooning. "Arthur Thomson's" anatomy is my recommendation for a complete and authentic textbook along this line. Get one anatomy book and stick to it — don't keep changing or it will confuse you.

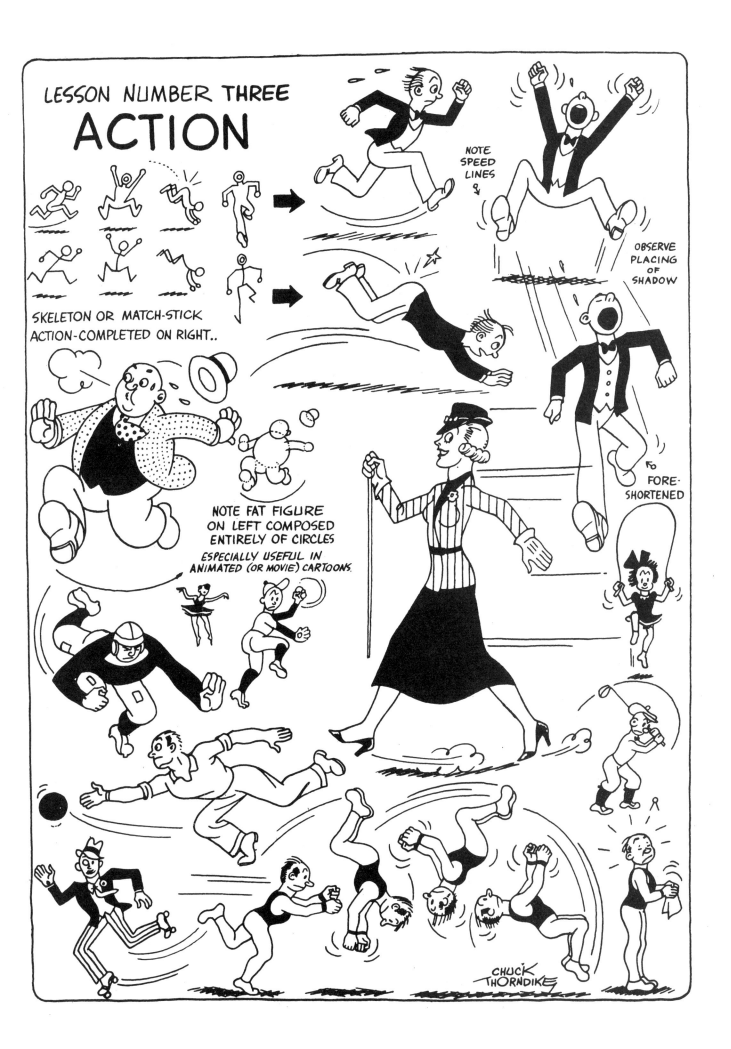

LESSON FOUR ... HANDS

Without a doubt the hardest form for the student to master thoroughly is hands. It is also the shape most frequently "out of drawing" with many cartoonists. In addition to the general formation of the hand, the size in relation to the body is often abused. The main requisite is uniformity — keep them the same relative proportion throughout your drawings and keep BOTH HANDS THE SAME SIZE. Hands are almost as expressive as the face — so don't regard them as unimportant. There are fifty different hand positions on the opposite plate so copy them, or, if necessary, use them for reference.

Learn the basic geometric shape of the hand, which is roughly, a square and a triangle, and they will be much easier for you. Copy your hands in the mirror when necessary. If you are making a drawing, such as hands holding a golf club, make the "grip" as authentic as possible. Draw the fingers like fingers really look and not just like a bunch of bananas.

Note the differences in construction between the hands of a man, a woman, and a child. The hands of a woman are the hardest to draw and my suggestion is that you save photographs of women's hands in fashion plates and file them in your morgue. If some position is hard for you don't try to use your imagination too much but either look up a reference or adopt a standardized position. A life class or drawing from casts should help you to photograph the shape of hands in your mind so thoroughly that you can develop a definite style of hand drawing that will become typical of your work.

DON'T USE TOO FEW STANDARDIZED POSITIONS, but vary them, make them expressive and give your stuff more "color."

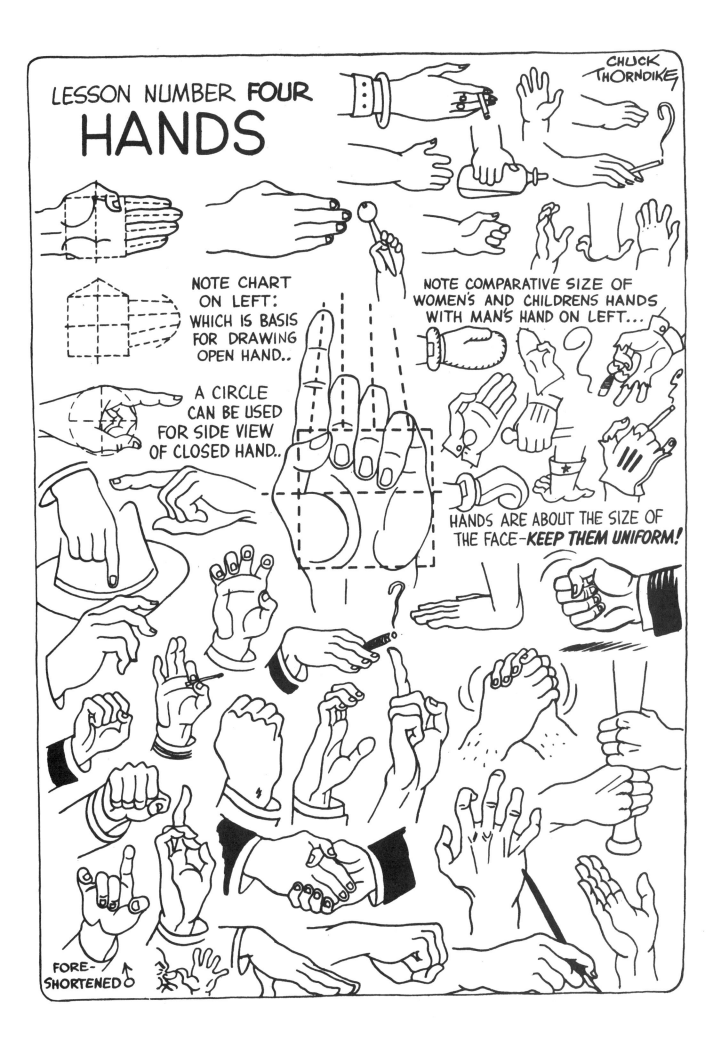

LESSON FIVE ... COLOR

Color is as necessary in a black-and-white drawing as it is in a painting, for effective results. Don't be afraid to paint in a solid black or draw a simple cross-hatch where they count — but avoid too many tricky effects. Give your technique the appearance of "careful carelessness" and not just a hasty afterthought. When using a black coat on a character it is better to keep the trousers white or striped. Polka dots or squares used on dresses are often effective.

The "Ben-Day" process is a helpful aid in obtaining shading effects that are mechanically uniform. In this process, the artist shades the portion of his drawing that he desires to be covered with one of the "Ben-Day" screen patterns. This shading is done with blue pencil. Then when the engraver makes the cut from the drawing, he has a means of making the particular design that you have picked out cover the area that you have designated by blue pencil shading. This process can be used only when a cut is being made from your original drawing. Get a catalogue of "Ben-Day" patterns from your engraver if you intend using them. Don't go in for spotty effects, but rather for mass effects when using "Ben-Day" screens.

Try not to get too much "flash" in your strips, comics, or cartoons but let one pattern predominate. Shadow or lighting effects are very striking when handled right. When doing backgrounds such as landscapes, etc., don't make them too important but merely incidental. The best way to get interesting detail for backgrounds is to make actual sketches of things around you such as trees, etc., and use them. In interior drawings a lounge or a chair and a picture or two are often enough. DON'T GET TOO MUCH DETAIL IN YOUR BACKGROUNDS or you will detract from your characters.

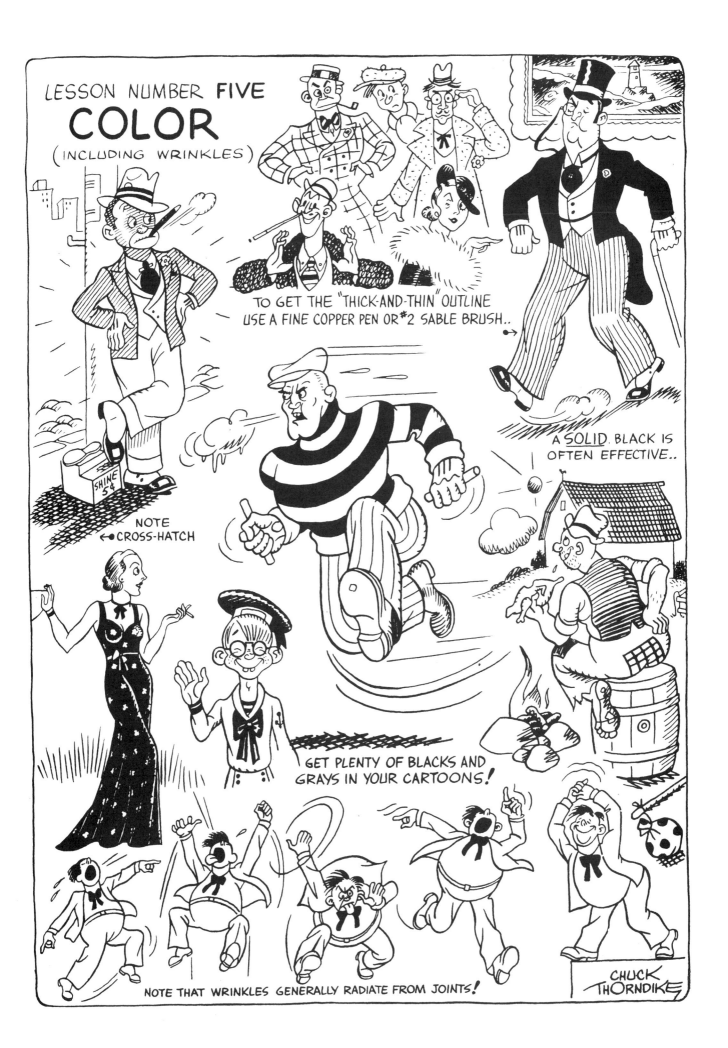

LESSON SIX ... HATS AND SHOES

On this plate, there are about forty different kinds of hats and about the same number of shoes. In drawing the hat it is, first of all, most necessary to make it FIT THE HEAD. Students almost invariably overlook this detail. If you will study the plate you will note how this can be overcome. As to hat types, clip all the pictures of hats you can find and put them in your "scrap" or "morgue" for your future reference. Be sure and use the right type of hat on your characters — don't put a minister's hat on a politician or vice versa as this is one of the surest ways for your reader to take pen in hand and start writing in "letters to the editor!"

Get the latest women's fashion magazines or booklets and keep them up to date for your styles in women's hats, as you will find the hat you drew on your girl character yesterday will be old-fashioned by tomorrow. It is a good idea to get a file of hats of various periods in your morgue for ready reference.

Feet are the "Jonah" of most students, with the result that they often regard them as unimportant. Many of the same rules on hands also apply to feet. In other words keep them simple, balanced, and uniform. Adopt a standard method of drawing feet or shoes in all positions and stick to your style. The block diagram on the plate will help you in drawing mens' shoes, but most of all, practice the points upon which you are obviously weakest.

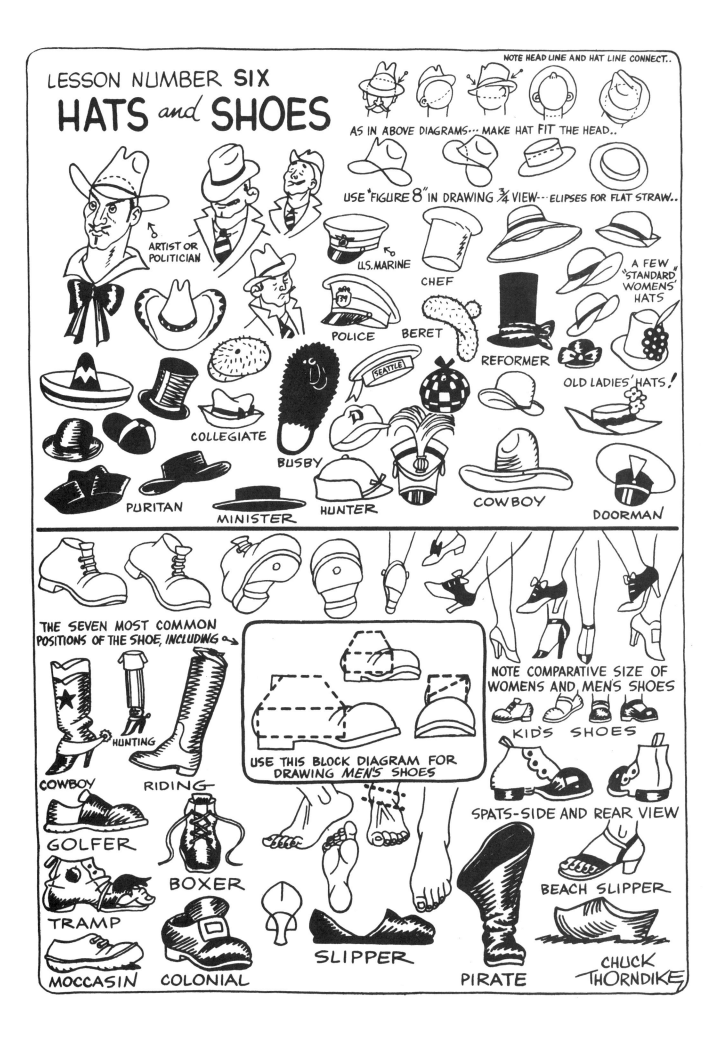

LESSON SEVEN ... TYPES

Everyone likes to attempt drawing someone else's likeness, and most people like to have their picture drawn. The modern cartoon is tending more and more toward realism. That is, your types should look like REAL people in exaggerated form. Too many students try to imagine their characters rather than sketch them from the people around in their everyday life. Readers want to see themselves, their friends, or neighbors in humorous drawings and not some strange phenomena not a part of their existence.

What may be extremely funny to you may not hit the bulls-eye with the one who passes final judgment — your reader or editor. Here again the best system is to make quick notes of the people, men, women, and children, you see around you in the bus, subway, or park and build your characters around these sketches.

Not all types are made in this manner, however, and this is particularly true of the political cartoonist. Such characters as the fat, stuffy plutocrat with the dollar signs in his checked suit depicting the "trusts" and created by Homer Davenport, the prohibition character created by Rollin Kirby, the "Joys" and "Glooms" created by T. E. Powers and other allegorical types such as Father Time, etc., are of course, made mostly from the artist's imagination. Many of these characters, however, such as Uncle Sam, are supposed to have been taken from living people. So, except in those rare cases where a character has to be entirely created, keep your types true to life.

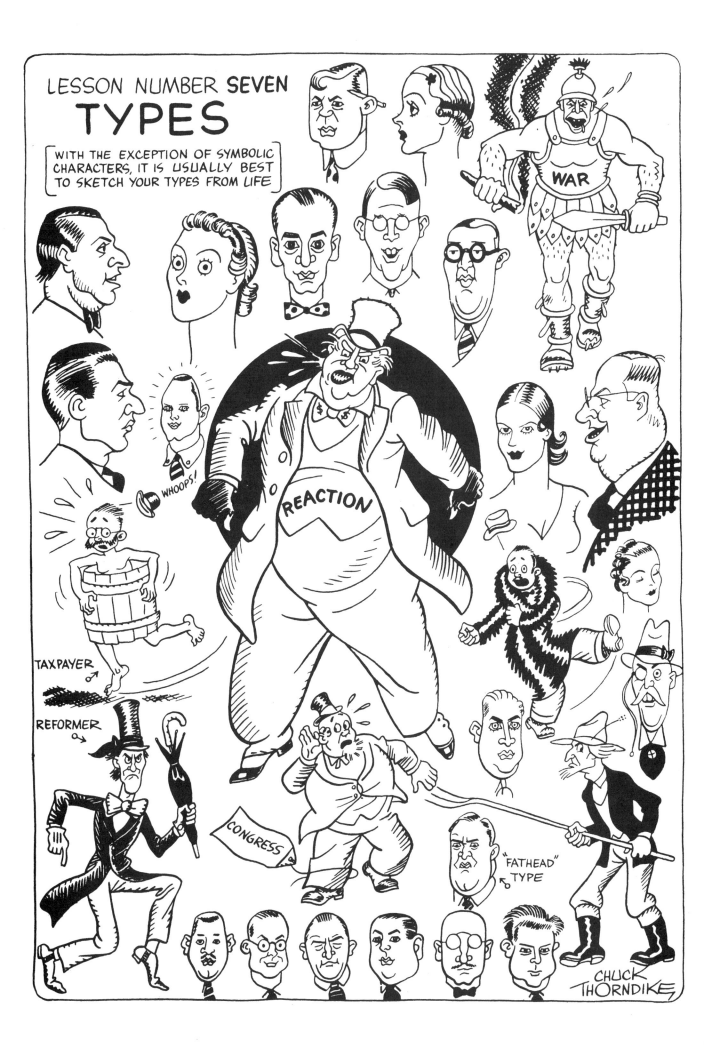

LESSON EIGHT ... ANIMALS

It is obviously impossible to get all the hundreds of animals, birds, fish, etc., on one plate. However, you will find here most of the more common varieties which will be often used in your drawings. The drawing of humorous animals is, of course, an art in itself and many cartoonists specialize in this phase alone. In political or sport cartoons they are especially useful. Undoubtedly the best drawn and most humorous animals today are to be found in animated cartoons. These animals are so human and lifelike that they give you the impression of being real people. While the animated cartoon style of drawing does not fit into every publication or newspaper, much can be learned by the student from watching them, especially as regards the types, action, and the round uniform style of drawing so necessary in animation. Another field where there is a demand for cartoon animals is in advertising. Of course, you will find lots of funny animals in the newspaper strips of today but there is not the demand for them in magazine comics that there was a few years ago.

You should save every type of animal for your morgue and as many different poses of the same type as you can. One of the best methods of getting the feeling of animal drawing is to sketch them at a zoo and file your sketches away for reference when you get a commission to do them. The more you can "humanize" your comic animals, the greater and more likeable appeal they will have for your readers. Before being allowed to create characters and "animate" them for the various movie cartoon concerns, an inexperienced artist, in this field, generally has to serve a long period as an "inker" or "opaquer" before being allowed to get into the higher-salaried jobs of more creative work.

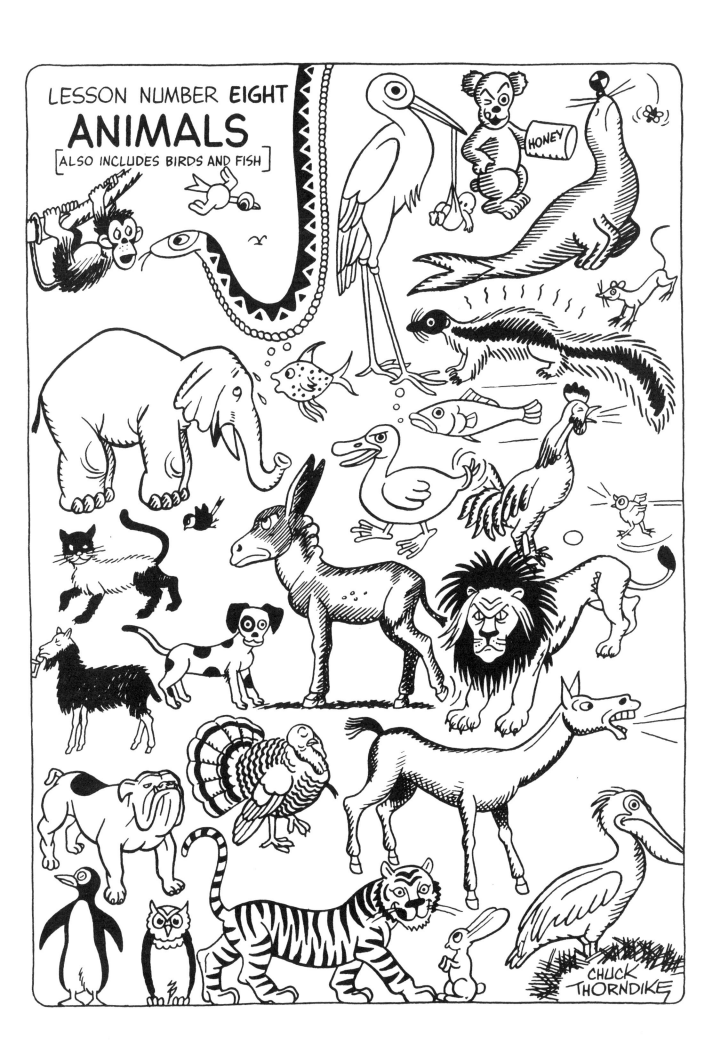

LESSON NUMBER **EIGHT**
ANIMALS
[ALSO INCLUDES BIRDS AND FISH]

CHUCK
THORNDIKE

LESSON NINE ... CARICATURES

The art of caricature is becoming more popular daily. There are really two kinds of caricature: the cartoon and the illustration. The cartoon caricature is usually an exaggerated portrayal of the physical characteristics alone, while the illustrative caricature gives you an insight into the personality of the subject through a medium of calculated emphasis.

To make a good caricature, the artist should make numerous quick notes of the subject from many angles. The more he knows about the victim's mannerisms and personality, the better the drawing. An inherent sense of humor is undoubtedly an asset in the art of caricature, but it can be developed through constant practice. One of the best training grounds for caricature work is a convention or any public assembly. Don't be self-conscious when making these sketches because your subject, if posing for you, will generally be patient as he or she wants a good picture, if you don't take too long. Anyone can be caricatured, no matter how uniform or good-looking their features may be. Of course, unless regular-featured people are very prominent they should be avoided and your attention concentrated on the faces with more unique features.

Use a very soft pencil for this work and keep a number of them sharpened and ready for use. If you can do both the head and body in some characteristic pose, instead of just the head, you will have a much more effective drawing. Remember you can never become "tops" in caricaturing unless you shake off that fear of drawing people. The caricaturist must have plenty of nerve, a good sense of humor, and he must be a lightning worker. The caricatures on this plate are all of well-known celebrities. Compare them with their photographs and then try some of your own.

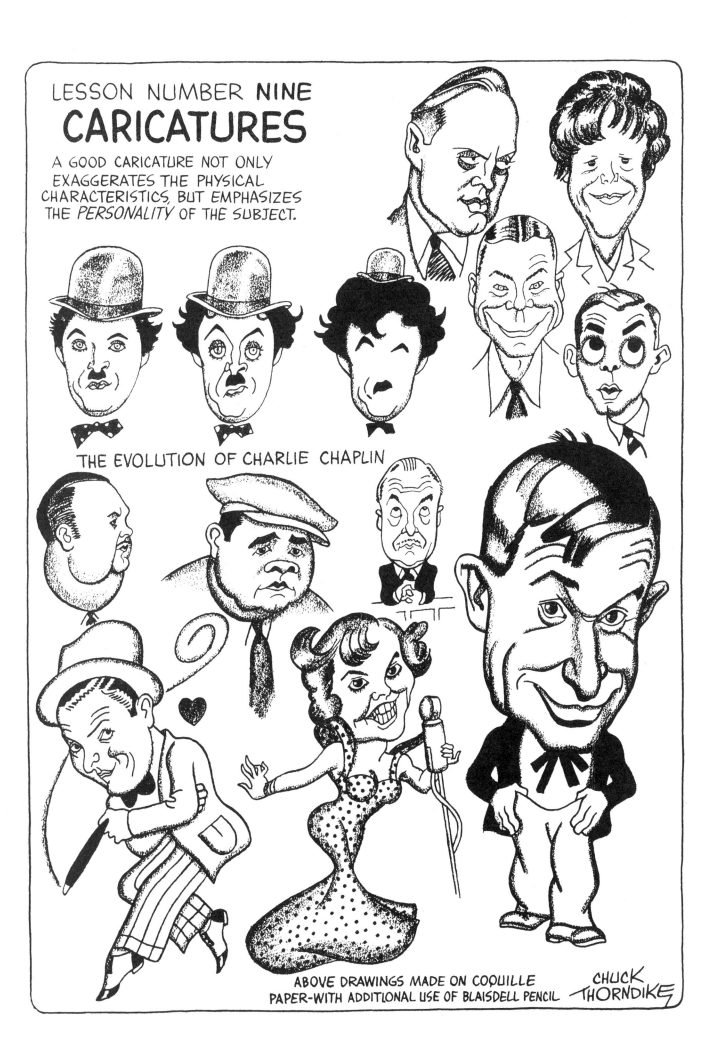

LESSON NUMBER NINE
CARICATURES

A GOOD CARICATURE NOT ONLY EXAGGERATES THE PHYSICAL CHARACTERISTICS, BUT EMPHASIZES THE *PERSONALITY* OF THE SUBJECT.

THE EVOLUTION OF CHARLIE CHAPLIN

ABOVE DRAWINGS MADE ON COQUILLE PAPER-WITH ADDITIONAL USE OF BLAISDELL PENCIL

CHUCK THORNDIKE

LESSON TEN ... LETTERING

Do not overlook the importance of clean, regular lettering. Only a few simple alphabets are necessary in cartooning but they should be thoroughly learned and practiced so that your work will be lifted above the "slapstick" or cheap form of cartooning. Lettering is not mechanical — it can have as much feeling as the drawing of a figure and gives a certain tone of refinement to your drawing that makes the effort well worthwhile.

Of course, lettering is used mostly in the comic strip or page and occasionally in advertising work. When doing a strip use a T-square and draw in your guide lines lightly, then pencil in your lettering FIRST before drawing your characters. Then draw in your balloons in pencil leaving plenty of "air" around your lettering and keeping both BALANCED and NEAT. After the characters are drawn the lettering should be inked in. This system prevents crowding and keeps the balloons at the TOP of the strip where they should be.

Remember it is not so much the shape of the letters themselves as it is the SPACE BETWEEN the letters that is important. For instance always keep your vertical letters up close to your round ones and also let your round letters, such as the "O," go slightly over the guide line. Don't let your letters get too tall but keep them rather squat and broad as they are more easily read this way.

A steady hand is most necessary to a good letterer and the best way to develop one is to practice alphabets constantly until you have them thoroughly mastered. Copy the chart on the opposite page over and over until you have it perfect.

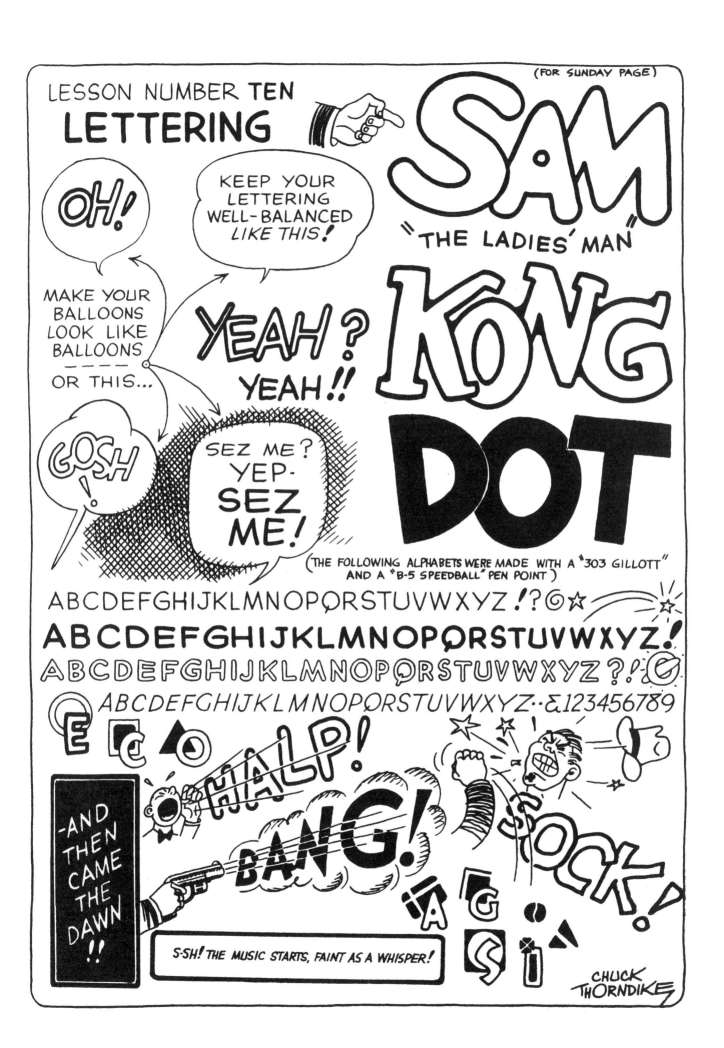

THE WASH DRAWING

Proper handling of the "wash medium" seems to come to the student only through constant practice and experience. Comparatively few artists have a natural feeling or ability to lay a smooth, clean wash on their drawing.

The first thing is to get the proper supplies. Don't use hot-pressed or smooth paper of any kind for this work. Use a cold-pressed paper of several ply if you can afford it, and remember that the better the paper or board, the better the job. A good grade of charcoal paper can be used, on comics for instance, if you're turning out a lot of them. Then use LAMP BLACK and not ink or poster black for your medium. Get a large sable wash brush that will cover the surfaces swiftly and SMOOTHLY. Keep your water clean and lay on the LIGHTEST TONE FIRST. If you use five tones such as: very light, medium light, medium, light black, and black you will have a sufficient variety. ABOVE ALL, don't let your wash DRY until you have fully covered the entire surface you have in mind, or the dried edges of the first application will stand out as dark streaks under your second layer of wash tone. You don't HAVE TO HURRY as good paper will remain MOIST for several minutes, but you must use extreme care.

Remember that your drawing will be reproduced either as a "square" halftone or a "drop-out" or "highlight" halftone. The square halftone is about one-third as expensive as the drop-out and is therefore more popular with some editors. This type must have square or rather "right-angle" borders and has a light tone over the whole cut. The "drop-out" has irregular borders and has spots of solid whites throughout the cut. Learn this distinction and above all, practice the wash continually.

THE SERIES CARTOON

In this type of drawing, the composition and design are most important. Note the distribution of solid blacks in the drawing on the opposite page. Also observe the placing of the Ben-Day screen to get the gray effect. In a decorative drawing of this kind it is best to use a fine copper pen point and keep an even outline, rather than using a thick-and-thin effect. The same style of drawing should be carried throughout a series of this type giving it a definite personality that can be recognized at once. Series drawings are easily the most interesting and profitable type of comic an artist can do for a magazine and they command the largest reader interest. This is one of a series of drawings that ran in a New York magazine for three years and was reprinted in many other publications throughout the country.

The best system in making this kind of series is to make your sketches right on the spot so that your detail and general atmosphere of the drawing are accurate.

(Cartoon reprinted through the courtesy of the Hotel New Yorker, New York City.)

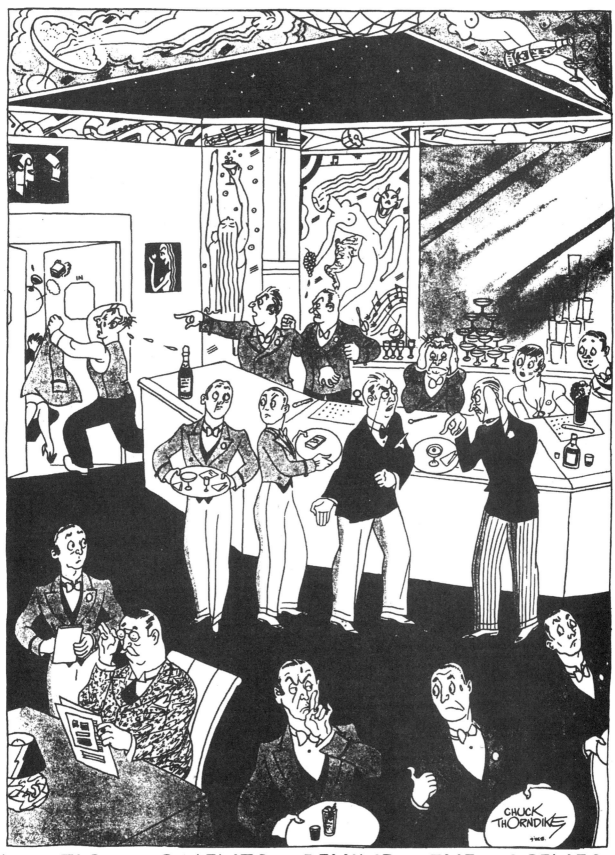

DRAMATIC MOMENTS BEHIND THE SCENES

● The assistant bartender who put a cherry in a dry martini

THE COMIC DRAWING

The success of a comic (or gag) drawing depends to a large extent upon the idea. With some magazines the idea is all-important, with others it's the style of drawing that counts most. Newspapers and syndicates are also using comics at this time more than ever before. Comics are usually done in rough form only to show the idea and are then taken or mailed to the editors.

One of the most-asked questions and one of the hardest to answer is: "How do comic artists get their ideas?" The answer is simply that they have that kind of a mind. Humorous ideas come to a typical gag man at any time, during a conversation or when walking along the street, because he has trained his mind to think, eat, and sleep gags. Many gag men keep a pencil and pad of paper by the side of their bed to capture ideas that come to them in the night. A rather strange commentary on human nature is that almost everyone thinks he is a humorist. As a matter of fact, however, most of the ideas brought to a humorist artist by his layman friends are pretty terrible and are also usually second-hand. The best course for an aspiring gag student to follow is to either sweat out his own ideas or to pay a good professional gag man a commission to furnish him with ideas. One of the best features of this type of work is that it can be carried out almost entirely through the mails — thus saving the artist a lot of wear and tear.

(Comics on the opposite plate used through the courtesy of the General Motors magazine, "News and Views.")

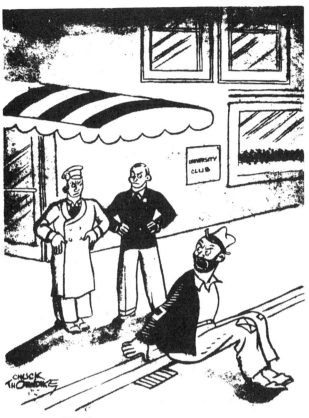

"That's no way to get new members!"

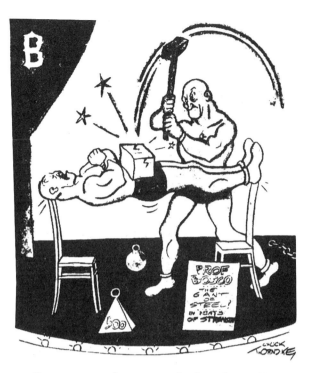

"Last summer, when crossing the channel, I couldn't keep a thing on my stomach!"

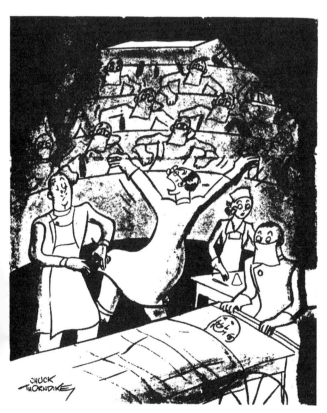

"All rigt, now, boys—a great big Rackety-rax for Dr. Glossock!"

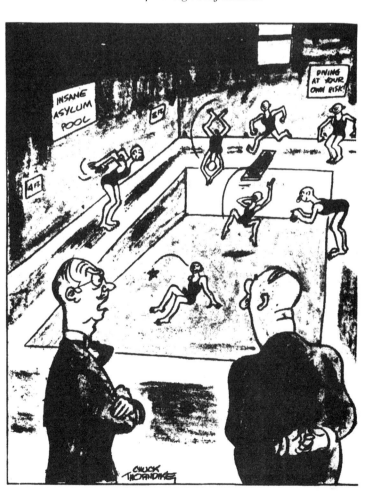

"They're having so much fun that we may not put in any water"

THE ADVERTISING CARTOON

The field of humorous advertising drawing demands a specialized knowledge of sales appeal in your drawings. It is also necessary to eliminate unnecessary detail in this work and to put in a punch so that the merchandize angle registers immediately with the reader.

The slapstick drawing seldom registers from the standpoint of selling appeal. The characters must be, in most cases, pleasant to look at and generally of the type that will not reflect adversely upon the product advertised.

It is also necessary that this type of cartoon be of the smart, unusual kind that will, because of its very nature, attract attention to the advertisement. Many firms use cartoon trademarks and pay very good money to their creators who originate them. People will usually pay more attention to a clever character of this kind than they will to pages of printed matter.

Advertising cartoons should be clearly defined and accurately drawn, because of the fact that they will probably be published many times and upon various different kind of news stock.

(Cartoons reprinted through the courtesy of Bradley Advertising Company, etc.)

THE SPORTS CARTOON

Both the sport cartoonists and the political cartoonists have interesting jobs, with the latter generally considered the "aristocrat" of the profession.

To do the better type of sport cartoons, a thorough knowledge of the human anatomy is required as well as familiarity with the various sports and ability to see the humor in different situations.

A good sports artist should be able to get a perfect likeness in a naturalistic portrait as well as in a caricature. He should also be able to make quick and accurate sketches at the ringside or at any sports event. Most artists in this field use a pantograph with which to make a drawing from a photograph and thus assure perfect proportions in the quickest time. Both a small brush or fine pen can be used, depending upon which the artist finds the easier to work with. Then lithographic pencil or crayon is used to put the solidity in the figure and give it color or shading.

This artist must be a rapid worker to get the flash news on paper in order to meet the "deadline" of his publication. He should also be able to make quick portraits and action sketches from life.

(Cartoons reprinted through the courtesy of Columbia University.)

LINES ON COLUMBIA'S LIONS...BY CHUCK THORNDIKE

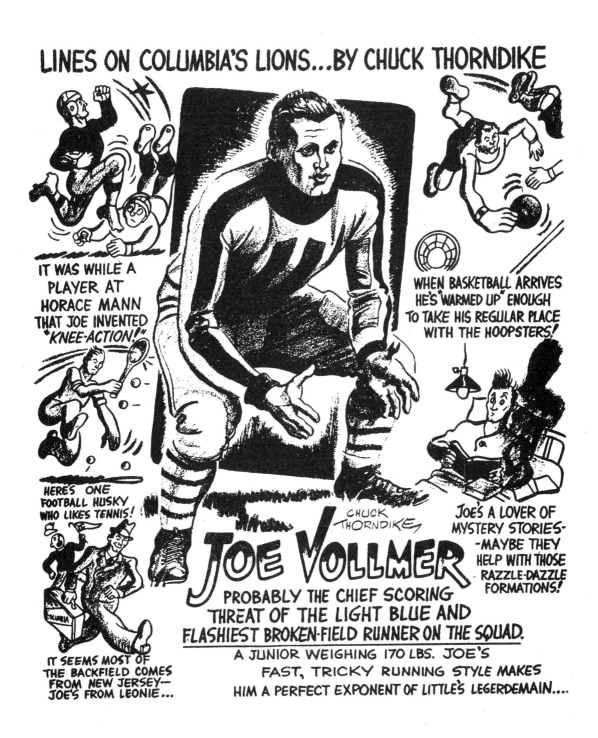

IT WAS WHILE A PLAYER AT HORACE MANN THAT JOE INVENTED "KNEE-ACTION!"

WHEN BASKETBALL ARRIVES HE'S "WARMED UP" ENOUGH TO TAKE HIS REGULAR PLACE WITH THE HOOPSTERS!

HERE'S ONE FOOTBALL HUSKY WHO LIKES TENNIS!

IT SEEMS MOST OF THE BACKFIELD COMES FROM NEW JERSEY— JOE'S FROM LEONIE...

CHUCK THORNDIKE

JOE VOLLMER

JOE'S A LOVER OF MYSTERY STORIES— -MAYBE THEY HELP WITH THOSE RAZZLE-DAZZLE FORMATIONS!

PROBABLY THE CHIEF SCORING THREAT OF THE LIGHT BLUE AND FLASHIEST BROKEN-FIELD RUNNER ON THE SQUAD.
A JUNIOR WEIGHING 170 LBS. JOE'S FAST, TRICKY RUNNING STYLE MAKES HIM A PERFECT EXPONENT OF LITTLE'S LEGERDEMAIN....

THE NEWSPAPER FEATURE

Of course, as in the "gag comic," the IDEA behind the strip or panel cartoon is of great importance. To get a spot with any syndicate your average editor will tell you that your ideas must be new and unusual. Other necessary qualifications to create reader-interest are the following: good drawing, humor, suspense, love, and human interest. If you have an idea for a feature, draw up from six to ten about two or three times the size of the features in the newspapers. Check the size of your drawings so that they will reduce in the proper proportions to the final size of actual use. If you are successful in placing your feature you will probably be given a contract which is usually on a 50–50% of the gross basis. Then you will be expected to keep your drawings worked up at least six weeks in advance of their release. This schedule is not an easy one to live up to and requires almost steady application, especially if you are also doing a Sunday colored page.

A photostat of the original full-page drawing is made and the artist of the syndicate colors this for the engravers guide. One of the best ways to get on with a syndicate is to get a job as "ghost" or assistant artist to an established cartoonist and learn all the ropes. The only other way I know of is to work up your features and keep after the syndicates until they either put you on or throw you out bodily.

(Cartoons reprinted through the courtesy of Van Tine Syndicate.)

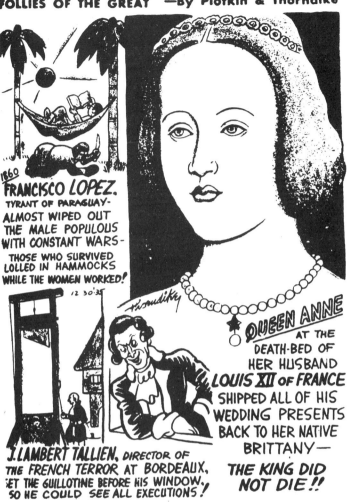

1860
FRANCISCO LOPEZ.
TYRANT OF PARAGUAY—
ALMOST WIPED OUT
THE MALE POPULOUS
WITH CONSTANT WARS—
THOSE WHO SURVIVED
LOLLED IN HAMMOCKS
WHILE THE WOMEN WORKED!

QUEEN ANNE AT THE
DEATH-BED OF
HER HUSBAND
LOUIS XII OF FRANCE
SHIPPED ALL OF HIS
WEDDING PRESENTS
BACK TO HER NATIVE
BRITTANY—
THE KING DID
NOT DIE!!

J. LAMBERT TALLIEN, DIRECTOR OF
THE FRENCH TERROR AT BORDEAUX,
SET THE GUILLOTINE BEFORE HIS WINDOW,
SO HE COULD SEE ALL EXECUTIONS!

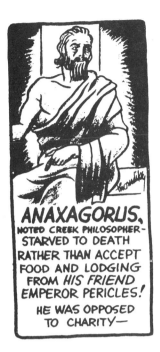

ANAXAGORUS,
NOTED GREEK PHILOSOPHER—
STARVED TO DEATH
RATHER THAN ACCEPT
FOOD AND LODGING
FROM HIS FRIEND
EMPEROR PERICLES!
HE WAS OPPOSED
TO CHARITY—

1450
QUEEN MARGERET.
WIFE OF HENRY VI OF ENGLAND,
SLEW THE DUKE OF YORK
(WHO CLAIMED HER HUSBAND'S THRONE)
AND PLACED A PAPER CROWN
ON HIS HEAD!

CZAR PETER THE GREAT
WORKED ON THE DOCKS IN
ENGLAND TO LEARN HOW
TO BUILD SHIPS FOR RUSSIA!

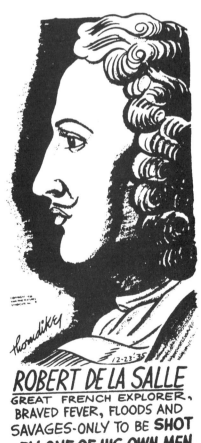

ROBERT DE LA SALLE
GREAT FRENCH EXPLORER,
BRAVED FEVER, FLOODS AND
SAVAGES-ONLY TO BE SHOT
BY ONE OF HIS OWN MEN
IN A QUARREL
OVER BUFFALO MEAT!

KEEPING A "MORGUE"

I cannot emphasize too strongly the importance of keeping reference clippings.

Students too often labor under the illusion that every detail of drawing should come from their imagination. This is not true as the very topnotch artists get some of their detail from photographs, newspaper and magazine clippings, and other authentic sources. So you are not "swiping" if you make your stuff ACCURATE by studying the detail of the work of specialists in their particular fields. This does not mean that you should "lift bodily" some particular picture and merely redraw it. It means if, for instance, you want to make a drawing of an English sheepdog, you should have a photograph or clipping of some other artist's drawing and make your own INTERPRETATION FROM THIS.

Save particularly the type of stuff that's hard for you to draw. For instance, a highly-imaginative student usually finds it difficult to draw mechanical subjects such as furniture, etc. While the more realistic artist has trouble with allegorical figures, etc. Of course, if you are specializing in a certain form of cartooning such as sports, it is best to save mostly pictures of celebrities in this field, action shots, etc. However, a WELL-BALANCED MORGUE is the best reference library for either the established artist or the aspiring student.

Following is a list of subjects on which you ought to have separate folders. When you are through with your clipping, return them immediately to their proper place.

I. ANIMALS
 1. Horses
 2. Dogs
 3. Cats
 4. Birds, etc.

II. MECHANICAL
 1. Automobiles
 2. Trains
 3. Aeroplanes
 4. Boats, etc.

III. COSTUMES
 1. Foreign
 2. Period
 3. Theatrical
 4. Pre-historic, etc.

IV. FAMOUS PEOPLE
 1. Living Men
 2. Living Women
 3. Historical Americans
 4. Historical Foreigners, etc.

V. FASHIONS (keep this up-to-date!)
 1. Womens
 2. Mens
 3. Childrens
 4. Babies

VI. ACTION
 1. Football
 2. Baseball
 3. Golf
 4. Tennis, etc.

VII. ALLEGORICAL
 (no sub-heads)

VIII. LETTERING
 (no sub-heads)

IX. LANDSCAPES
 (no sub-heads)

X. MISCELLANEOUS
 (no sub-heads)

The Art of Cartooning

THE AUTHOR

The author of "The Art of Cartooning" and "The Secrets of Cartooning" has been drawing cartoons for over 25 years . . . Starting as a contributor to high school publications in Seattle, Washington, he then moved to San Francisco where he worked on the San Francisco Bulletin and also drew animated or movie cartoons in both San Francisco and Los Angeles . . . While enlisted in the U.S. Marines during the World War, he contributed to several service publications . . . Three years of art school followed this experience during which he contributed to several college publications . . . Then came the trip to New York where he served as art director for General Motors, different advertising agencies, and national magazines at various times. He is also a contributor to several newspaper syndicates and to the *Saturday Evening Post, Judge, College Humor,* and other national magazines besides several foreign publications . . . During the last year he has entered radio work conducting a series of interviews with prominent cartoonists which added greatly to the author's reputation.

FOREWORD

"The Art of Cartooning" is published primarily to cover the needs of thousands of cartoonists, students and art teachers for a more advanced form of cartoon instruction.

It is based upon questions asked by the purchasers of my first and more elementary book "The Secrets of Cartooning," which in its first year of publication broke all volume sales records for any book of its kind. It is also based upon the further requirements of those students in my personal cartoon classes.

"The Art of Cartooning," like "The Secrets of Cartooning" is complete in itself as a series of lessons. By adding the review questions I feel that I have added value to "The Art of Cartooning."

The answers to most of the questions appended to each lesson can be found by reference to the charts or the text. Where the question requires a students' own observation or knowledge, this question is indicated by a * (star). The answer to the question so marked will not be found in the book.

LESSON ONE ... ANATOMY
HEAD-PROFILE

In lesson one of "The Secrets of Cartooning," I explained the fundamental geometric shapes necessary upon which to base a cartoon head. On the opposite page is shown the superficial anatomy of the profile head, knowledge of which is necessary to make a complete and intelligent portrait, modernistic drawing, or cartoon of the same form.

You should not always try to just draw what you actually SEE, but draw what you KNOW is there. Most students concentrate too much upon *unnecessary detail* and thus lose the feeling of diametric symmetry which is essential in the modern school of art. Economy of line should be practiced in all your efforts. By learning thoroughly that anatomy which affects the form you will not be eternally groping in the dark.

I have reduced these anatomical charts to their simplest fundamentals thus not only making them easier to learn, but giving you the opportunity to concentrate only upon the IMPORTANT FORMS. In drawing a profile, whether it be a portrait, caricature, or cartoon FIRST DRAW A SQUARE. Then draw in carefully the shape of the head. By measuring, if necessary, you can easily ascertain whether the head shape fits the square. If it doesn't (which is often the case) the guide lines can be removed. NEXT LOCATE THE POSITION OF THE EYE. Then draw in very carefully the PROFILE LINE which is the most important line of the head from this angle. Next LOCATE THE EAR and don't be afraid to use the guide lines as shown. Then draw in your jaw angle and lower maxillary process (that part of the jaw bone running from the jaw angle to the end of the chin) and the sternomastoid muscle. The temporal arch, Zygomatic crest, and muscles are the forms which help determine your lighting effects.

REVIEW QUESTIONS

1. Upon what horizontal lines is the "second widest" part of the head usually found?
*2. In what respect does the skull of modern man differ from that of the Neanderthal man?
3. Is the sinus bone projection as prominent in the male profile as it is in the female profile?
4. In using the head (from the bottom of the chin to the top of the head) as a unit of measure, do you measure from the top of the hair or the top of the skull?
5. What is the average distance from the iris of the eye to the bridge of the nose?

*See foreword

ANANTOMY
LESSON ONE—

DRAW THIS SIMPLE OVAL AND DIVIDE IT...

THEN ADD THE SQUARE FOR "FACE" OF SKULL...

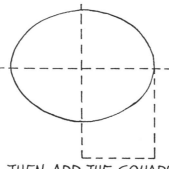

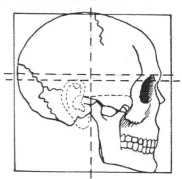

ADD THE DETAILS OF FEATURES NEXT AS SHOWN ABOVE..

FIRST STUDY THE <u>SHAPE</u> OF THE HEAD AND THEN THE CONSTRUCTION OF BONES AND MUSCLES - *THE PROFILE LINE OF THE FEATURES CARRIES MOST OF THE LIKENESS - GET IT PERFECT!*

IT IS THE PURPOSE OF THIS BOOK TO REDUCE ANATOMY CONSTRUCTION TO ITS VERY SIMPLEST AND BASIC FORMS BY THE USE OF GEOMETRIC CHARTS AND THE PRINCIPLES OF DIAMETRIC SYMMETRY—

THE MORE IMPORTANT CONSTRUCTION PRINCIPLES BROUGHT OUT ON THESE ANATOMY PLATES ARE APPLIED TO FINISHED DRAWINGS LATER ON IN THE BOOK BY USE OF TISSUE OVERLAYS.

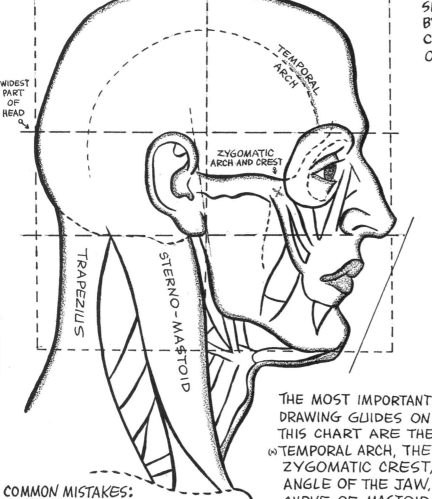

WIDEST PART OF HEAD

TEMPORAL ARCH

ZYGOMATIC ARCH AND CREST

TRAPEZIUS

STERNO-MASTOID

THE MOST IMPORTANT DRAWING GUIDES ON THIS CHART ARE THE TEMPORAL ARCH, THE ZYGOMATIC CREST, ANGLE OF THE JAW, CURVE OF MASTOID MUSCLE AND EAR POSITION..

NOTE RELATION OF SKULL TO MUSCLES AND CARTILAGES OF FACE AND BALANCE ON SPINAL COLUMN..

COMMON MISTAKES:
CRANIAL BOX NOT DRAWN WIDE ENOUGH
EYE PLACED TOO HIGH IN HEAD
EAR DRAWN OUT OF RELATION TO GUIDE LINES
EYE DRAWN TOO CLOSE TO BRIDGE OF NOSE.
JAW ANGLE DRAWN OUT OF RELATION TO MOUTH

LESSON TWO ... ANATOMY
HEAD-FRONT VIEW

First of all, compare the muscle forms as shown in this chart with those in the profile view (see lesson one). When their location is learned thoroughly you can apply them to the head when drawn from ANY ANGLE. Note the geometric shapes at the top of the page. The simpler and more basic you can tell your drawing story the less irritating and more pleasing it will be to your audience.

This is the first time, to my knowledge, that anatomical diagrams have been applied to humorous drawing in a book. It is true that some artists "get by" with a tricky technique or slapstick drawing, but they are in the minority and have been unduly favored by Lady Luck. One good rule to always remember is that "the eye sees color but the MIND sees form." There are reasons for the shapes and lines on a person's face and the reasons are either muscles or bone structure. I want you to note especially the cartoon head with the light and dark values. Whenever a light is thrown on a face, the FORM of the face naturally shapes the shadows. Remember too in the case of a portrait or larger modernistic head it is usually necessary to show the "between tone" that is the halftone between the light and dark values showing the roundness of the form.

Many students are afraid to copy, measure, or use guide lines having such an innate belief in their own ability that they don't believe it necessary. THIS IS ALL WRONG. You can't TRUST your eyes — it's your brain that does the drawing through your arm, hand, and fingers and your eyes merely see the result.

Don't let the Latin names throw you — as a matter of fact, whether you know Latin or not, they are easily translated into their English derivatives.

REVIEW QUESTIONS

1. What is the average width of the space between the eyes?
2. What is the geometric shape of the head from the front?
3. If a vertical plumb line were dropped down from the tear duct of the eye, it generally touches the borders of what feature?
4. There are broadly three different types of chins. Name the types.
*5. After the student draws the geometric shape of the head, what is the next step?

*See foreword

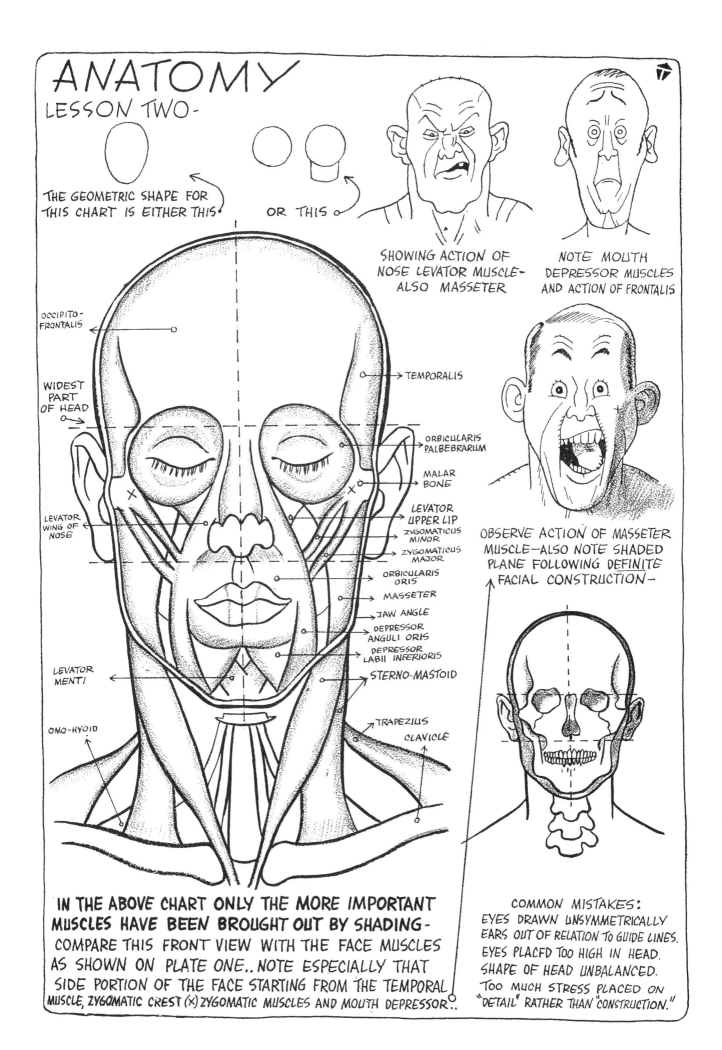

ANATOMY
LESSON TWO-

THE GEOMETRIC SHAPE FOR THIS CHART IS EITHER THIS·

OR THIS

SHOWING ACTION OF NOSE LEVATOR MUSCLE- ALSO MASSETER

NOTE MOUTH DEPRESSOR MUSCLES AND ACTION OF FRONTALIS

OCCIPITO- FRONTALIS

TEMPORALIS

WIDEST PART OF HEAD

ORBICULARIS PALBEBRARUM

MALAR BONE

LEVATOR UPPER LIP

LEVATOR WING OF NOSE

ZYGOMATICUS MINOR

ZYGOMATICUS MAJOR

ORBICULARIS ORIS

MASSETER

JAW ANGLE

DEPRESSOR ANGULI ORIS

DEPRESSOR LABII INFERIORIS

LEVATOR MENTI

STERNO-MASTOID

OMO-HYOID

TRAPEZIUS

CLAVICLE

OBSERVE ACTION OF MASSETER MUSCLE—ALSO NOTE SHADED PLANE FOLLOWING DEFINITE FACIAL CONSTRUCTION—

IN THE ABOVE CHART ONLY THE MORE IMPORTANT MUSCLES HAVE BEEN BROUGHT OUT BY SHADING- COMPARE THIS FRONT VIEW WITH THE FACE MUSCLES AS SHOWN ON PLATE ONE.. NOTE ESPECIALLY THAT SIDE PORTION OF THE FACE STARTING FROM THE TEMPORAL MUSCLE, ZYGOMATIC CREST (X) ZYGOMATIC MUSCLES AND MOUTH DEPRESSOR..

COMMON MISTAKES: EYES DRAWN UNSYMMETRICALLY EARS OUT OF RELATION TO GUIDE LINES. EYES PLACED TOO HIGH IN HEAD. SHAPE OF HEAD UNBALANCED. TOO MUCH STRESS PLACED ON "DETAIL" RATHER THAN "CONSTRUCTION."

LESSON THREE ... ANATOMY
MALE FIGURE

On this plate you will note that I have drawn on the left the bones of the male figure. I have also named the more important bones and I suggest that you learn them thoroughly. By using the length of the skull as a measuring unit you will note that the length of the body is seven and a half heads.

Below this drawing you will observe that I have drawn the muscles of the body and their relation to the bones. I have also named the more important muscles and I suggest that you learn them thoroughly. Please remember that there is no such thing as EVENLY-BALANCED or DUMB-BELL form in either the arms or the legs. These shapes are ALWAYS on the BIAS as clearly shown by the OBLIQUE GUIDE LINES on the muscle chart. Study the length, junctures, and shapes of the muscles thoroughly as they are MOST IMPORTANT to you in humorous drawing if you wish to get your work out of the "slapstick" class. If you wish to become thoroughly proficient in your work you should be able to draw both of these charts from memory.

Now note the SIMPLIFIED GEOMETRIC CHARTS I have drawn on the right to help you create your comic figure action. Observe how closely they apply to the comic illustrative figures to their right. The first step is to draw the oval for the head (be sure to TILT it right) then draw in your neck lines, then the SLANT of the shoulders, after this draw in the CURVE OF THE TORSO ACTION. The next step is to draw in the elipse for the SHAPE AND SLANT of the pelvis, after this draw a single line to show the action of the arms and legs. By using the small circle you will get your arm and leg joints EVENLY and CORRECTLY placed. This is a very important lesson. Copy it many times and learn it thoroughly.

REVIEW QUESTIONS
1. Name the longest bone in the human anatomy.
2. Does the curve of the muscle generally follow the curve of the bones?
3. Can you find parallel shapes in the arms and legs?
4. Is there one projection or two in the pelvic region from the front view?
*5. Will a superficial knowledge of anatomy improve the work of a cartoonist?

*See foreword

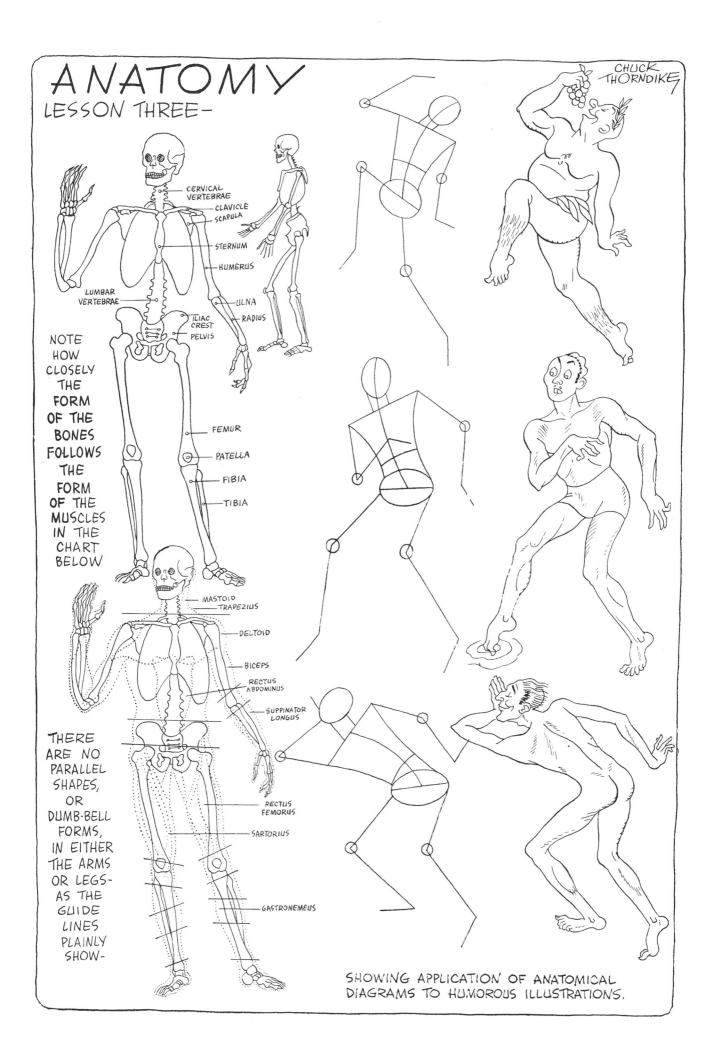

ANATOMY
LESSON THREE—

CHUCK
THORNDIKE

CERVICAL
VERTEBRAE

CLAVICLE
SCAPULA

STERNUM

HUMERUS

LUMBAR
VERTEBRAE

ULNA

RADIUS

ILIAC
CREST

PELVIS

NOTE
HOW
CLOSELY
THE
**FORM
OF THE
BONES
FOLLOWS**
THE
**FORM
OF THE
MUSCLES**
IN THE
CHART
BELOW

FEMUR

PATELLA

FIBIA

TIBIA

MASTOID
TRAPEZIUS

DELTOID

BICEPS

RECTUS
ABDOMINUS

SUPPINATOR
LONGUS

THERE
ARE NO
PARALLEL
SHAPES,
OR
DUMB-BELL
FORMS,
IN EITHER
THE ARMS
OR LEGS-
AS THE
GUIDE
LINES
PLAINLY
SHOW-

RECTUS
FEMORUS

SARTORIUS

GASTRONEMEUS

SHOWING APPLICATION OF ANATOMICAL
DIAGRAMS TO HUMOROUS ILLUSTRATIONS.

LESSON FOUR ... ANATOMY
FEMALE FIGURE

It is an established fact that a well-proportioned female figure is the most beautiful form in art. It is true that it is difficult to find a near perfect model. She may have a beautifully shaped or even exotic type head and her legs and arms may be perfect rhythms of curves, but her breasts may be flat and sagging or her hips too large. An experienced artist can of course, eliminate these defects but it naturally follows that the better the model the better the results. A good model must also KNOW HOW TO POSE GRACEFULLY and KEEP HER POSE. Hogarth's famous "line of beauty" had its origination in the female nude. (this is technically a long curve and a reverse short curve)

The majority of cartoonists even the professionals, cannot draw beautiful modern women. Naturally, the work of these cartoonists who have this gift is in much demand. If you can join a croecus or life class by all means do so and attend regularly. No matter how talented or well-known an artist may be he is always more or less a student.

Note in the opposite chart the directional line showing the curve of the torso on female figure at left of the plate. Observe also curving guideline keeping arms and hands at even length and balance. In as much as the weight of the figure is on the right, the right hip (or iliac crest and also great trocanter) is higher than the left. Note that the line of the breasts follow the shoulder line. Now apply this knowledge to the anatomical charts on the right and see how closely they follow the humorous illustrations. Your girls must be pretty, modern as to hairdress and figure, and above all FASHIONABLY DRESSED!

REVIEW QUESTIONS

1. Does the line of the breasts change with the line of the shoulders?
2. Is the center of a woman's body exactly half-way from the top of the head to the soles of the feet?
3. Do the legs and arms extend in an exact straight line?
*4. Can Hogarth's "line of beauty" generally be found in a female nude? If so, where?
5. About how many heads tall is the female figure when seated?

*See foreword

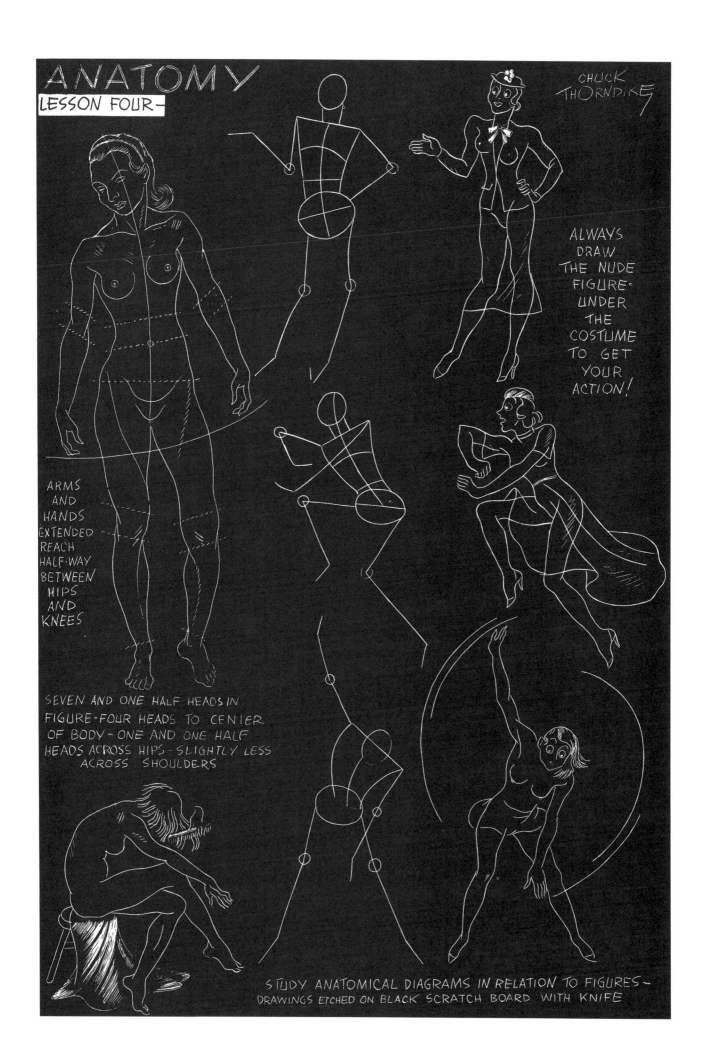

ANATOMY
LESSON FOUR—

CHUCK THORNDIKE

ALWAYS
DRAW
THE NUDE
FIGURE·
UNDER
THE
COSTUME
TO GET
YOUR
ACTION!

ARMS
AND
HANDS
EXTENDED
REACH
HALF·WAY
BETWEEN
HIPS
AND
KNEES

SEVEN AND ONE HALF HEADS IN
FIGURE - FOUR HEADS TO CENTER
OF BODY - ONE AND ONE HALF
HEADS ACROSS HIPS - SLIGHTLY LESS
ACROSS SHOULDERS

STUDY ANATOMICAL DIAGRAMS IN RELATION TO FIGURES -
DRAWINGS ETCHED ON BLACK SCRATCH BOARD WITH KNIFE

LESSON FIVE ... ANATOMY
MALE, FEMALE, CHILD

In this chart, notice especially the CENTER BALANCE LINE of the figures walking. In this position, the body weight is almost entirely upon one foot and therefore, to maintain the balance of the body, it must be in the center or directly below the head. Compare the differences between the man, woman, and child. The female figure is longer in the torso, narrower through the shoulders, and wider at the hips than the figure of the male. A baby is about four heads long, a child of five about six heads, a child of nine about six-and-a-half heads. Study the proportional measurements as explained in the chart and DON'T DISREGARD THEM AS UNIMPORTANT. Try to get movement in your shoulder, hip, and torso guidelines, thus getting the action in your entire figure.

Kids are very interesting to draw for a great number of reasons. They should always be drawn in cute attitudes though their mannerisms and "ulterior motives" can be very sophisticated. The tendencies in the modern cartoon is to depict the child in both speech, action, and expressions as knowing more about "the facts of life" than their parents.

It is quite essential to show definitely the AGE of the child in your drawings. Remember that the YOUNGER the child the larger the cranial box or skull in relation to the rest of the face. A baby's eyes are about one-third the distance from the bottom of the chin to the top of the skull. Students invariably make the mistake of drawing the cranial box TOO SMALL in a child. Also study the head proportions in regard to the various ages as shown in the plate. Kids are too nervous to pose long and therefore, you must make quick or memory sketches of them

REVIEW QUESTIONS
1. Does the spine or backbone of a baby have as many curves as that of an adult?
2. Is a woman's body as wide through the shoulders as a man's?
3. Is a woman's body as wide through the hips as a man's?
4. Does a girl of five have the same relative body proportions of a fully-grown woman?
*5. Is there much relative physical differences in body proportions between a boy of five and a girl of five?

*See foreword

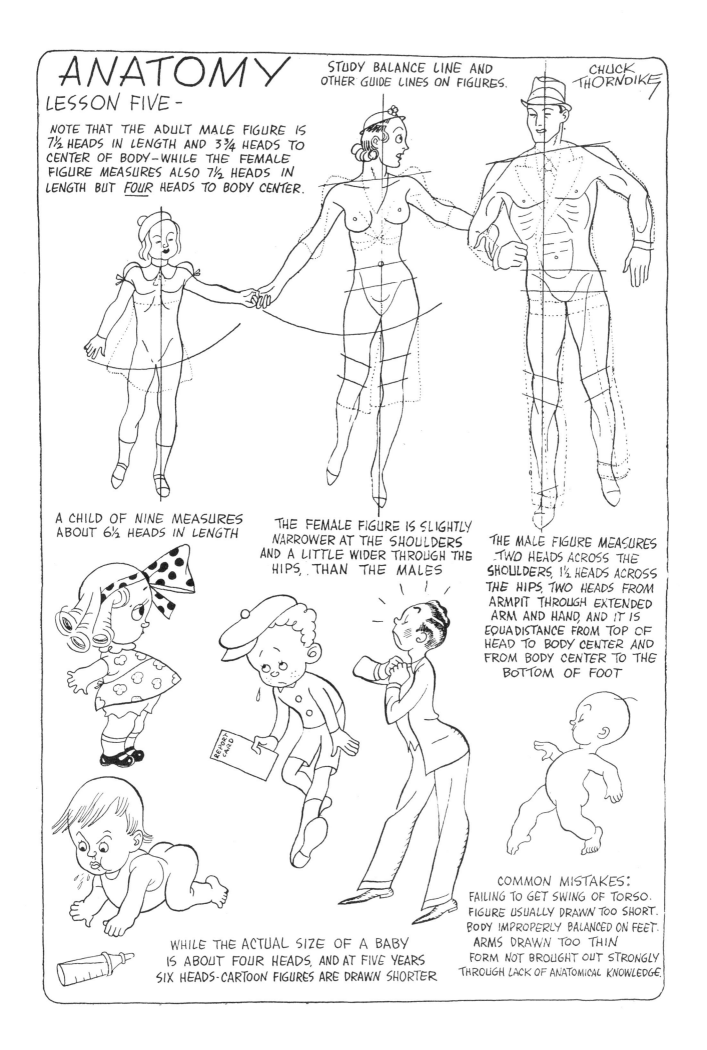

ANATOMY

LESSON FIVE -

NOTE THAT THE ADULT MALE FIGURE IS 7½ HEADS IN LENGTH AND 3¾ HEADS TO CENTER OF BODY—WHILE THE FEMALE FIGURE MEASURES ALSO 7½ HEADS IN LENGTH BUT FOUR HEADS TO BODY CENTER.

STUDY BALANCE LINE AND OTHER GUIDE LINES ON FIGURES.

CHUCK THORNDIKE

A CHILD OF NINE MEASURES ABOUT 6½ HEADS IN LENGTH

THE FEMALE FIGURE IS SLIGHTLY NARROWER AT THE SHOULDERS AND A LITTLE WIDER THROUGH THE HIPS, THAN THE MALES

THE MALE FIGURE MEASURES TWO HEADS ACROSS THE SHOULDERS, 1½ HEADS ACROSS THE HIPS, TWO HEADS FROM ARMPIT THROUGH EXTENDED ARM AND HAND, AND IT IS EQUADISTANCE FROM TOP OF HEAD TO BODY CENTER AND FROM BODY CENTER TO THE BOTTOM OF FOOT

REPORT CARD

WHILE THE ACTUAL SIZE OF A BABY IS ABOUT FOUR HEADS, AND AT FIVE YEARS SIX HEADS-CARTOON FIGURES ARE DRAWN SHORTER

COMMON MISTAKES:
FAILING TO GET SWING OF TORSO.
FIGURE USUALLY DRAWN TOO SHORT.
BODY IMPROPERLY BALANCED ON FEET.
ARMS DRAWN TOO THIN
FORM NOT BROUGHT OUT STRONGLY
THROUGH LACK OF ANATOMICAL KNOWLEDGE.

LESSON SIX ... CARICATURES
ACTRESSES

I have been asked so many questions about CARICATURES that they have been featured to a large extent in this book. J. M. Barrie once wrote that happiness is not found in doing as you like — but in liking the things you have to do. I think that in the field of cartooning this is particularly true of caricature. It is caricature that probably approaches that mystical throne of "fine arts" more than any other form of humorous drawing. It is a field that requires special training, special ability, and most of all special desire. The life of your averaged recognized caricaturist has been and is no proverbial bed of roses because caricature like poetry is a criticism of life. Most caricaturists believe quite sincerely that we have only one means of coping with the fantastic events and characters which dominate life. We can be amused. In other words a smile can be better than a revolution and a pencil more convenient than a gun. Many people look upon it as an avocation rather than a vocation. Caricature has been defined as "a portrait in which the defects are exaggerated." A caricaturist, however, must not only be able to exaggerate outstanding physical features but he or she should be somewhat of an innocent mind reader and character-analyst capable of piercing the fog of human pretense.

Well, the truth will out, so I must tell you that the caricatures on the plate are of Edna May Oliver, Katharine Hepburn, and Claudette Colbert. Incidentally you must remember that your caricatures should, if possible, tell a story. In other words use "props" to get your idea over. Hepburn for instance reminds me at times of a "weeping willow" while again she seems to be sort of floating on top of the world. Alexander Woollcott is often shown as an "owl," Ann Pennington as a "frog," Fanny Ward as a "baby" — while other people are shown representing just about everything else.

REVIEW QUESTIONS

1. Can you name a noted personage that reminds you of an owl?
2. Can you name a famous dancer who reminds you of a frog?
3. What does Katharine Hepburn remind you of?
4. Can you name a famous person who in your opinion reminds you of something similar in the animal kingdom?
*5. Must a caricature head always be drawn large, as in the case of a very tall person?

*See foreword

CARICATURES

CHUCK
THORNDIKE

LESSON SIX –

TRY TO GET "PROPS" OR SUPPORTING
IDEAS INTO YOUR CHARACTER TRANSLATIONS.

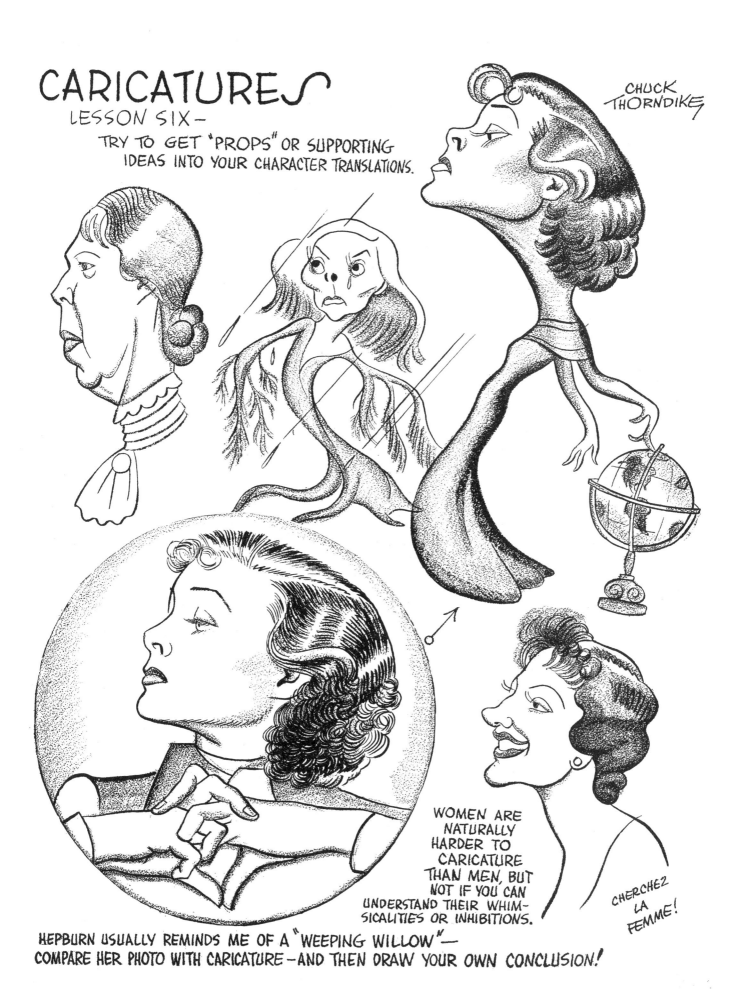

WOMEN ARE
NATURALLY
HARDER TO
CARICATURE
THAN MEN, BUT
NOT IF YOU CAN
UNDERSTAND THEIR WHIM-
SICALITIES OR INHIBITIONS.

CHERCHEZ
LA
FEMME!

HEPBURN USUALLY REMINDS ME OF A "WEEPING WILLOW"—
COMPARE HER PHOTO WITH CARICATURE – AND THEN DRAW YOUR OWN CONCLUSION!

LESSON SEVEN ... CARICATURES

You get three guesses as to the people caricatured on this plate! Note that in the upper-left-hand corner we have a "straight" or naturalistic portrait of Franklin D. Roosevelt, while to the right of this are shown the various notes necessary in making the different transitions to a caricature. Such seeming irrelevant things as the slant of the eyeglasses, the wrinkles around the nose and mouth and the size, slant, and placement of the ear are VITALLY IMPORTANT.

Roosevelt has a strong massive head expressing plenty of good character and joviality. These traits must be brought out definitely in your caricature. He also has a habit of throwing his head back and indulging in a hearty laugh. Observe how this is brought out in both the profile and three-quarters caricature immediately below. The Blaisdell pencil technique (gray tones) is applied to bring out the form of modelling of his face, thus adding to the likeness. Immediately below these are caricatures of Eleanor Roosevelt and John Nance Garner. These three great leaders are "naturals" for caricature. To the left of Mrs. Roosevelt's caricature is drawn a small naturalistic portrait. Compare these two drawings and see how the exaggeration is applied.

Probably the outstanding characteristics about Mr. Garner are his bushy eyebrows, the shape of his head, and the mode of his dress. It is only by studying these various things and then applying them in an extremely designed form that you can get both humor and likeness in your drawing. Study these drawings carefully, compare them with photographs, and then copy every sketch on the plate over until you have them down perfectly.

REVIEW QUESTIONS

1. Can you get better results from just any photograph of a subject or should it be really typical?
2. Are some angles of a face more suitable for caricature than others?
3. What is the first step in drawing a caricature?
4. Should your caricature be instantly recognized?
*5. Do public personages, as a general rule, like to have themselves caricatured? If so, give some examples.

*See foreword

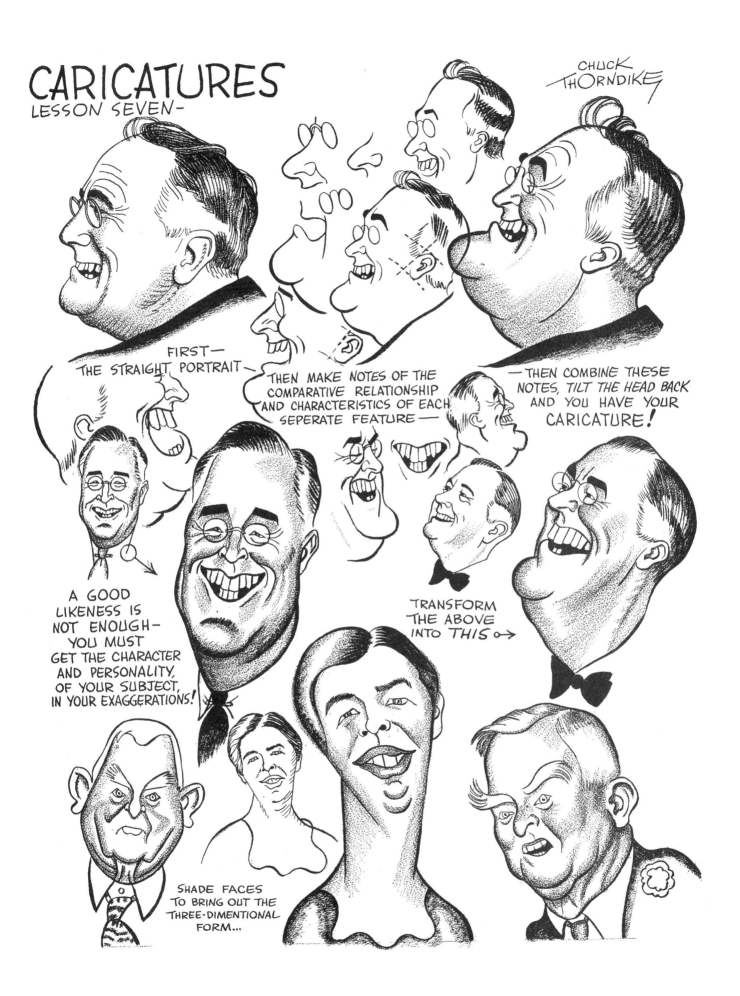

LESSON EIGHT ... CARICATURES

"As soon as an artist has acquired a facility in drawing a head he may amuse himself in alternating the distances of the various lines, marking the places of the features whereby he will produce a variety of odd faces that will both please and surprise him." These rules laid down by a Captain Francis Grose in 1788 apply today.

In the lower left hand corner of this chart, I have drawn the actual silhouette shape of the heads of Jimmy Durante and George Burns. Next to these shapes are the caricatures of them. To my mind GETTING THE EXAGGERATED SHAPE OF THE HEAD is the first step in making a caricature. Of course, you must "over-estimate" the outstanding parts of the physiognomy to the point where it is humorous but not to the point where YOU LOST THE LIKENESS. Most important, I believe is to catch your victim in a TYPICAL or CHARACTERISTIC expression or pose, whether you be drawing from stills or from life. It is sometimes necessary to make many notes and changes before this effect can be achieved. Your caricature should be instantly recognized and above all, unusual. Of course, if your reader does not happen to know your subject there isn't much you can do about it. Caricatures can be experimented with in many techniques. Those of Wheeler and Woolsey, for instance are drawn with charcoal while those of Laurel and Hardy are done with a fine pen-and-ink outline and lamp-black wash.

You should, however, first do all your drawing with a soft pencil until you can develop some knack for caricature before experimenting around with too many trick effects.

REVIEW QUESTIONS

*1. Does the addition of a wash effect or pencil shading usually help bring out the likeness in a caricature, if so why?

2. Is it possible to make caricatures of certain people using only a single line? Can you name a few possible subjects?

3. Do you believe it expedient to use a "conservative" caricature under certain conditions rather than an "extreme" one?

4. Should a caricaturist know the mannerisms of his subject quite thoroughly in order to incorporate them in his drawing?

5. Do you believe that certain subjects adapt themselves to certain treatments in drawing techniques? Give a few examples.

*See foreword

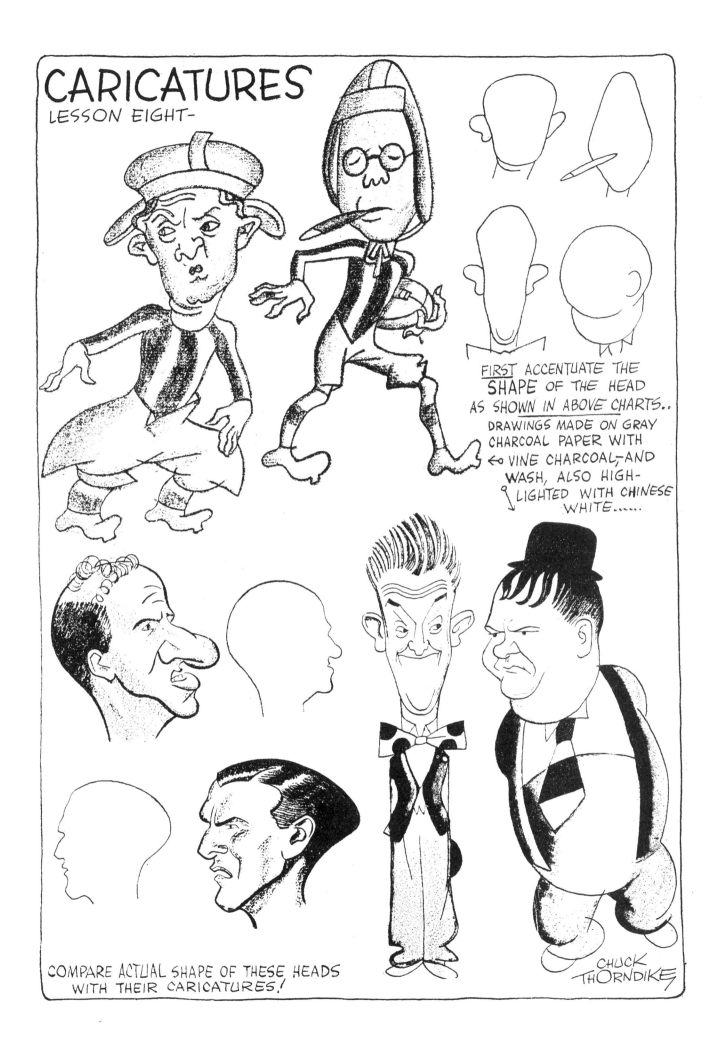

CARICATURES
LESSON EIGHT—

FIRST ACCENTUATE THE **SHAPE** OF THE HEAD AS SHOWN IN ABOVE CHARTS.. DRAWINGS MADE ON GRAY CHARCOAL PAPER WITH VINE CHARCOAL—AND WASH, ALSO HIGH-LIGHTED WITH CHINESE WHITE......

COMPARE ACTUAL SHAPE OF THESE HEADS WITH THEIR CARICATURES!

CHUCK THORNDIKE

LESSON NINE ... CARICATURES
MOVIE COMICS

This plate, as you will note, is composed entirely of caricature heads of movie comics.

In the upper-left-hand corner, we have a portrait of Joe E. Brown and below this his caricature. These portraits have been placed in this plate together with their caricature, to give the student the opportunity of comparison. The chief points of exaggeration are; changing the size of his hat to give added expression to the face, slanting eyes and shortening his nose, lengthening upper lip, and, of course, widening the mouth. The chief points of exaggeration with Zazu Pitts are: enlarging the expressive eyes, shortening the nose, lengthening the upper lip, drawing down mouth, and shortening the chin. The chief points of exaggeration with Slim Summerville are: widening the top of the head and making the neck narrow, enlarging the ear and nose, making the eye and chin smaller, and the upper lip longer. Note also that the double chin is made more prominent.

The caricatures of the rest of the comics shown on the plate are obtained by exactly the same method. I would suggest that you obtain photographs of them and compare them with the drawings.

Now cover up the caricatures I have made and make a few translations of your own of the portraits at the top of the plate.

REVIEW QUESTIONS

1. Are movie comics more adaptable to caricatures than players of straight parts?
2. Is it a good idea to put a neck and collar on a head caricature?
*3. If you were drawing "props" for this plate what would you suggest as a suitable idea for Zazu Pitts?
4. Would you call the arrangement of heads on this plate even or uneven balance?
5. In your opinion what is the easiest head on this plate to caricature? And why?

*See foreword

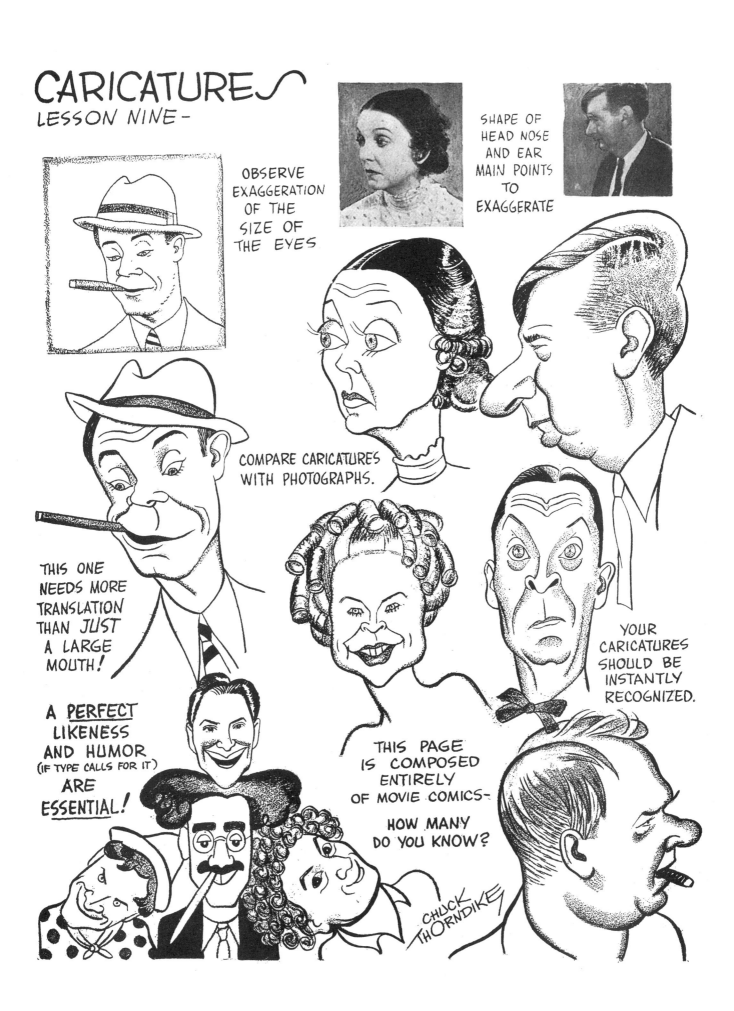

CARICATURES
LESSON NINE—

OBSERVE EXAGGERATION OF THE SIZE OF THE EYES

SHAPE OF HEAD NOSE AND EAR MAIN POINTS TO EXAGGERATE

COMPARE CARICATURES WITH PHOTOGRAPHS.

THIS ONE NEEDS MORE TRANSLATION THAN *JUST* A LARGE MOUTH!

A **PERFECT** LIKENESS AND HUMOR (IF TYPE CALLS FOR IT) ARE ESSENTIAL!

YOUR CARICATURES SHOULD BE INSTANTLY RECOGNIZED.

THIS PAGE IS COMPOSED ENTIRELY OF MOVIE COMICS—

HOW MANY DO YOU KNOW?

CHUCK THORNDIKE

LESSON TEN ... CARICATURES
WORLD FIGURES

Just in case you don't recognize the gentlemen on the opposite page, I'll let you in on the secret. They are Edward, the Duke of Windsor, Mussolini, and Hitler. Of course, if you have recognized them — the world is mine.

My reason for this chart is to show you the application of various techniques.

In the upper-left corner, the face is first caricatured and inked in, together with the tam and scarf. Then the face is covered with tracing or frisket paper (touched down with rubber cement) and then ink is spattered on lightly by drawing the ink quill across a toothbrush. This same technique is used on the caricature of Hitler in the lower-right corner, with the additional use of dry brush and Blaisdell pencil.

Often an interesting effect can be obtained by confining the gray shadows or modelling to the face only, as in the caricature at the top center.

In the lower-left-hand corner Mussolini is caricatured by the technique, application of "dry-brush" only. Some very interesting effects can be obtained in this medium. Care must be taken, however, to see that the bristles of the brush are evenly spaced and that it has just enough ink on it. Note especially that the outline on the two bottom figures is quite HEAVY because of the amount of color and the STRENGTH of the figures depicted.

The chart on the opposite page is symmetric balance because of the arrangement, if they were uneven it would be dynamic balance.

REVIEW QUESTIONS
1. Do you consider the use of spatter work effective in political cartoons?
2. Are good results obtained by using "dry-brush" on political cartoons?
*3. Name five other "trick" effects used in the creation of caricatures besides these shown.
4. Would you call the arrangement of the caricatures on this plate dynamic or symmetric balance?
5. Would you draw Mussolini with a heavy strong outline to show his character?

*See foreword

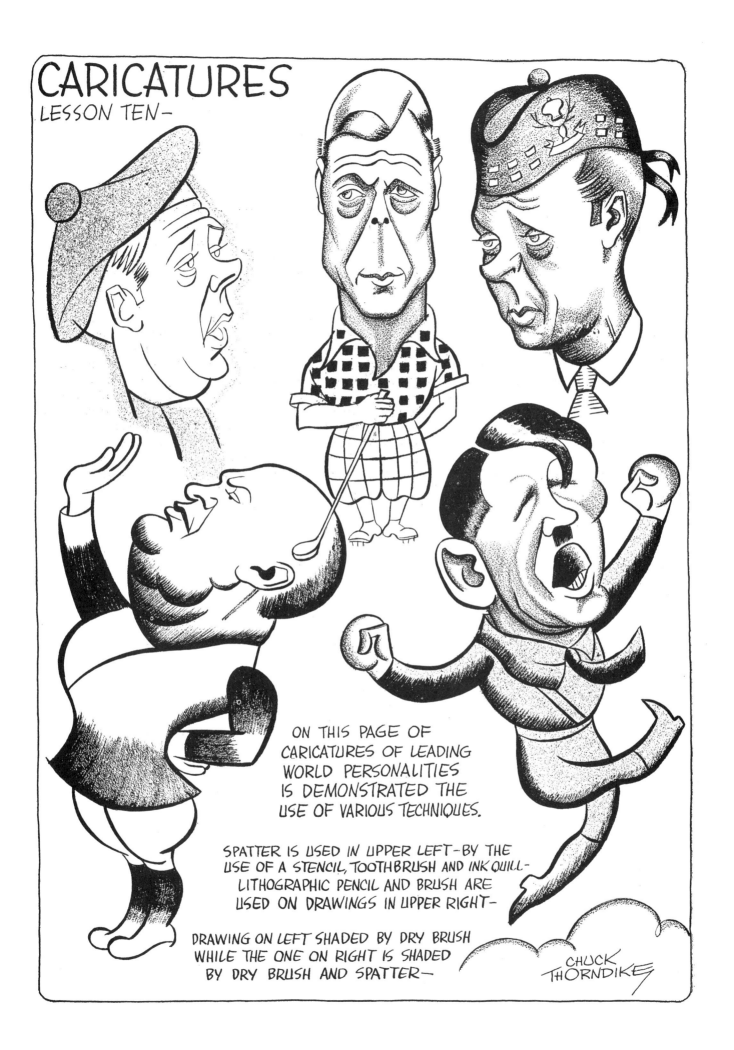

LESSON ELEVEN ... TECHNIQUES

This plate though it may appear mechanical is very important to study and practice, if you want your work to look professional. You must have clean, sharp pen or brush ink lines in your drawings if you want them to REPRODUCE PROPERLY. Don't always blame poor reproductions on the engraver. Quite often the poor plate results are the fault of the artist because he hasn't taken the proper patience and care with his technique.

In the upper left hand corner is reproduced a "white-on-black" effect that can be obtained on scratch board. This board is coated with a chalk surface and (if it's white scratch board) an even amount of lamp black and black India ink is then laid on with a brush. This coating must be applied smoothly and evenly. Then draw on this surface with a white pencil the cartoon or design you want. You then scratch these lines out with a sharp knife and in this way very effective results are obtained. Below this is shown a sample of "coquille" drawing paper, upon which both lithographic crayon and Blaisdell pencil have been applied. There are several other patented drawing papers such as "Rosco-stip" Ross board, Glarco board, etc., upon which excellent results can be obtained. Spatter work, such as shown below this, is very effective when used in propaganda or political cartoons. The stipple, while good to use at times, should be avoided as much as possible, as it is tedious work and somewhat mechanical.

On the right side of the plate are shown various pen and brush technique EXERCISES. Practice these over and over until you have them as even and uniform as those shown on the plate.

REVIEW QUESTIONS

1. Can a "dry-brush" effect be obtained with color as well as with black ink?
*2. Would you use the same pen point for drawing thick-and-thin lines that you would use for lettering?
3. Do you believe cross-hatch technique should be even and uniform?
4. Should you practice technique exercises with a brush as well as the pen?
5. Is coquille paper an effective medium for political cartoons?

*See foreword

TECHNIQUES
LESSON ELEVEN-

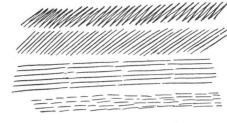

PRACTISE ABOVE TECHNIQUE STROKES FOR SHADING EFFECTS.

USE THIS CUTTING KNIFE WHEN ETCHING ON SCRATCH BOARD.

LEARN TO CONTROL YOUR PEN STEADILY IN THE THICK-AND THIN LINE.

EITHER WHITE OR BLACK SCRATCH BOARD CAN BE USED TO GET ABOVE EFFECT. PAINT MIXTURE OF LAMP BLACK AND INDIA INK ON THE WHITE BOARD-THEN SCRATCH SURFACE WITH KNIFE POINT.

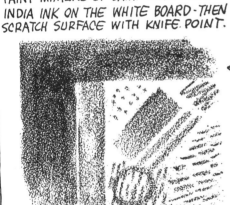

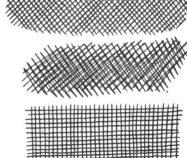

FOR BROAD STROKES USE A CRAYON WITH HOLDER, UNDER HAND, AS SHOWN ABOVE.

CROSS-HATCH SHADING MUST BE UNIFORM TO BE EFFECTIVE..

LITHOGRAPHIC PENCIL OR CRAYON USED ON COQUILLE PAPER OR ROSS BOARD PRODUCES ABOVE EFFECT

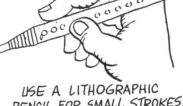

USE A LITHOGRAPHIC PENCIL FOR SMALL STROKES.

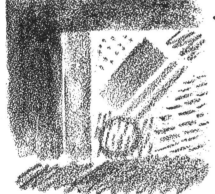

SPATTER WORK-CUT A STENCIL IN FRISKET OR TRACING PAPER, THEN SCRATCH INK QUILL ON TOOTH BRUSH.

DRY BRUSH IS A VERY EFFECTIVE MEDIUM, ESPECIALLY IN POLITICAL OR POSTER CARTOONS. JUST DRY YOUR BRUSH OUT ON A BLOTTER AND KEEP YOUR STROKES UNIFORM.

STIPPLE EFFECT AS SHOWN ABOVE PRODUCED BY SIMPLY MAKING DOTS WITH A BALL-POINTED PEN.

CHUCK THORNDIKE

ANIMATED CARTOONS

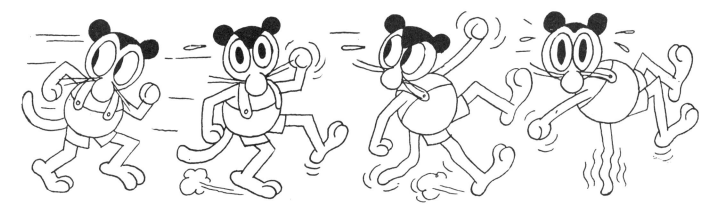

In as much as there is a universal interest in the making of animated or movie cartoons a special introduction for these lessons seems to be in order.

First of all, hundreds of students throughout the country are anxious to get jobs drawing for the movies. Other students or artists are constantly writing or asking me what special ability or aptitude they must have or be able to acquire in order to get located in this fascinating field. Naturally, it is interesting work and this ambition is easy to understand.

I would say that first of all these people desirous of getting in this line of work should have a "professional and native style of drawing." Secondly they should have an original and profuse sense of humor and have plenty of what it takes to make them pantomine comedians. Remember this is a specialized field and to succeed you should have or develop "the actor" in you. Frankly too many students and others look for some "short-cut" to success in their work — this is nice work if you can get it, but application and original thinking are the much safer method and pay bigger dividends in the long run.

Artists who draw animated cartoons generally are specialists. In other words it is their life work. Naturally these few lessons will not necessarily put you in line for a job. If you study them carefully, however, you will get the basic idea of the talent that is needed in order to get one.

Now how is the sound applied to the cartoon drawings on the film? It seems most people are interested in the answer to that question. Well, in a general way here is how it's done: — first of all, the sound director, sound effect men, musicians, and vocal artists gather in the projection room and watch the film while it is being run — then the picture is run again and the artist, musicians, etc., contribute their part at the proper time. The actual recording being slower than the projection of the picture, but this is corrected through mechanical light contrivance.

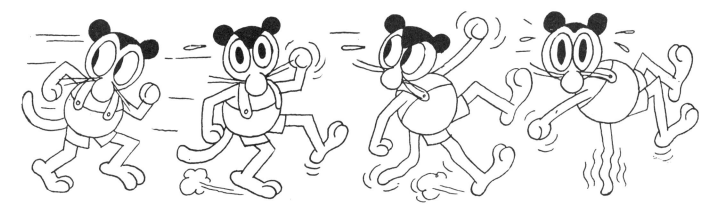

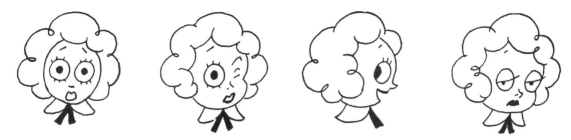

Microphones pick up the sounds and music and this is carried by wires to a sound-proof room. Here a wax and film record is made, the record is called a "take" and the film record is called a "sound track." This record is played back while the cartoon film is projected a third time. The mistakes in this record are caught and the necessary corrections made for the second "take" which is to follow. It is sometimes necessary to follow this procedure several times before a perfectly synchronized record is made. The film "sound track" is then developed and transferred to the cartoon film.

ONE OF THE FIRST NECESSARY STEPS IN DRAWING AN ANIMATED CARTOON.

OR A COMIC STRIP, IS THE ORIGINATION OF YOUR CHARACTERS.

LESSON TWELVE ... ANIMATED CARTOONS

The first animated cartoon was worked out by Thomas Edison, assisted by Commodore Stuart Blackston along about 1900. However, "The Sinking of the Lusitania" produced a few years later by Windsor McCay is generally conceded to be the original pioneer film. This film involved 16,000 separate drawings and required twenty-two months to make. It also netted approximately $80,000 or $5.00 per drawing which beats the returns on many of our modern films.

"Bertha, the Dinosaur" and the "Little Nemo" series were next produced by McCay in animated cartoon form and it is because of these productions that he is considered the pioneer producer of the film cartoon. Until about 1922, this type of cartoon was made with paper cut-outs then placed on a hand-painted background and photographed. They are now made almost entirely with thin celluloid sheets which are placed one on top of another to get the desired effect. No more than three of these sheets can be used at a time, however, as the background or bottom sheet becomes too dark for clear photography.

It requires about five movements to produce the effect of a man putting a cigarette into his mouth. From two to four more drawings to put his head in a natural manner and from four to six for him to blow a cloud of smoke up to the top of the scene. Many times an action can be reversed and repeated by using the same set of drawings. Of course, these drawings require perfect register at all times because they are magnified many times when on the screen and errors or "jumps" are irritating to the audience.

After the scenario department and artists finish a release, the drawings then have to be photographed. Until recently four one-thousand candlepower lights were used to illuminate the drawings while being photographed. This caused such intense heat that the photographer often had to wear a hat to keep his hair from being singed.

REVIEW QUESTIONS

1. How many sheets of celluloid can be used at one time when photographing?
2. Are paper cut-outs generally used today in animation?
*3. What in your opinion would be the easiest animal to animate and the most difficult?
4. Is the style of an illustrative cartoonist generally suitable for the type of drawing required in animation?
5. Do you think a cartoonist has to be more or less of a specialist in order to be successful in animation?

*See foreword

ANIMATED CARTOONS
LESSON TWELVE-

COPY THIS CHARACTER ON ONE-PLY
DRAWING PAPER — THEN RIFFLE
THE DRAWINGS AND STUDY THE ACTION.

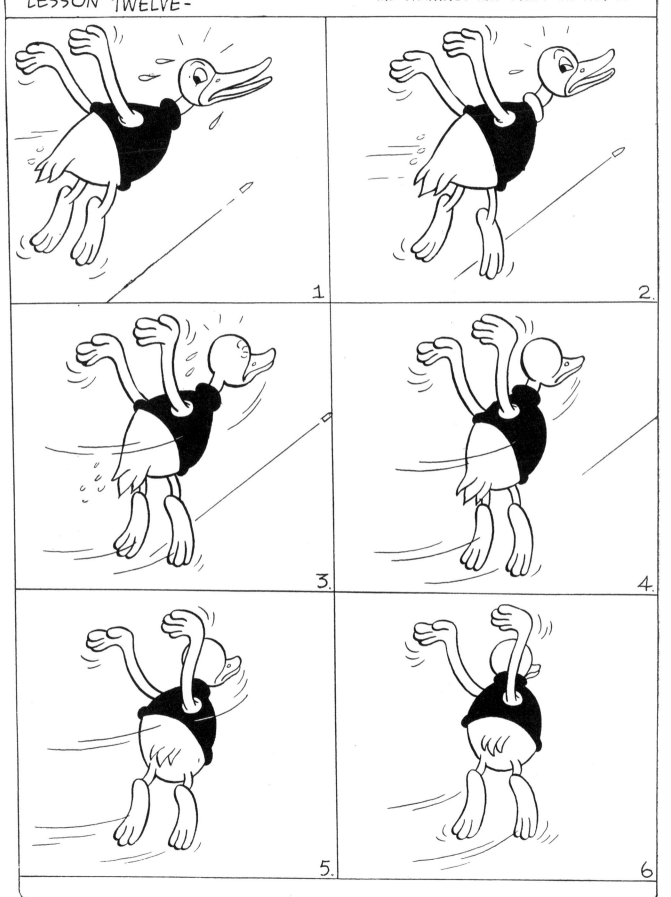

LESSON THIRTEEN ... ANIMATED CARTOONS

Most studios today use mercury vapor light tubes which eliminate heat and give just as much light. The number of exposures given each drawing depends, of course, upon the speed of the action required. Usually, however, one exposure is given to each drawing, except in cases where a pause or hesitating motion is used and which requires slower action. In this case three or four exposures are given to the same drawing at the descretion of the photographer.

One gag used sometimes is called the "trick-grind." This work on the theory that the slower the photography, the faster the action and is used in certain shots such as those showing the hand of an artist drawing a cartoon. This particular grind produces only one exposure or frame at each complete revolution of the crank, while normal photography exposes a foot of film or sixteen frames with the same motion. Other stunts used in this department are the "iris" and the "fade." The former is sometimes made by a series of circular cutouts on black cardboard or by the camera itself, while the latter is made by a diaphragm which cuts down the power of the lights.

Naturally, an army of people are required to turn out a modern animated cartoon. Walt Disney, for example, needs about one hundred and fifty specialists in his production department alone. These include animators, tracers, inkers, opaquers, scenario and gag writers, sound effect men and women, singers musicians, etc. The production starts in the scenario department. Here they attempt to work out the entire plot, if possible, and if not, they work out a complete sequence with the assistance of a quick sketch artist. This sequence is then turned over to the expert animators and background artists who work out roughly the action and scenery to be used. The quick pencil sketches are then turned over to the inkers who trace over these paper sketches on the celluloid sheets in ink and then pass them on to the opaquers who paint in the black-and-gray tones used for the color.

REVIEW QUESTIONS

1. In a running action (from side to side) is it possible for both the character and the background to move?
*2. Name four human qualities an animated character should have to become popular.
3. In a colored animated cartoon is the color painted on the drawings or on the film?
4. Does it help an animated cartoonist to "act-out" certain difficult positions himself in order to get better drawings?
5. Do regular progressive drawings make better animation than irregular ones?

*See foreword

MAKE UP A BIRD CHARACTER OF YOUR OWN, FOLLOWING PRINCIPLES IN THIS LESSON.

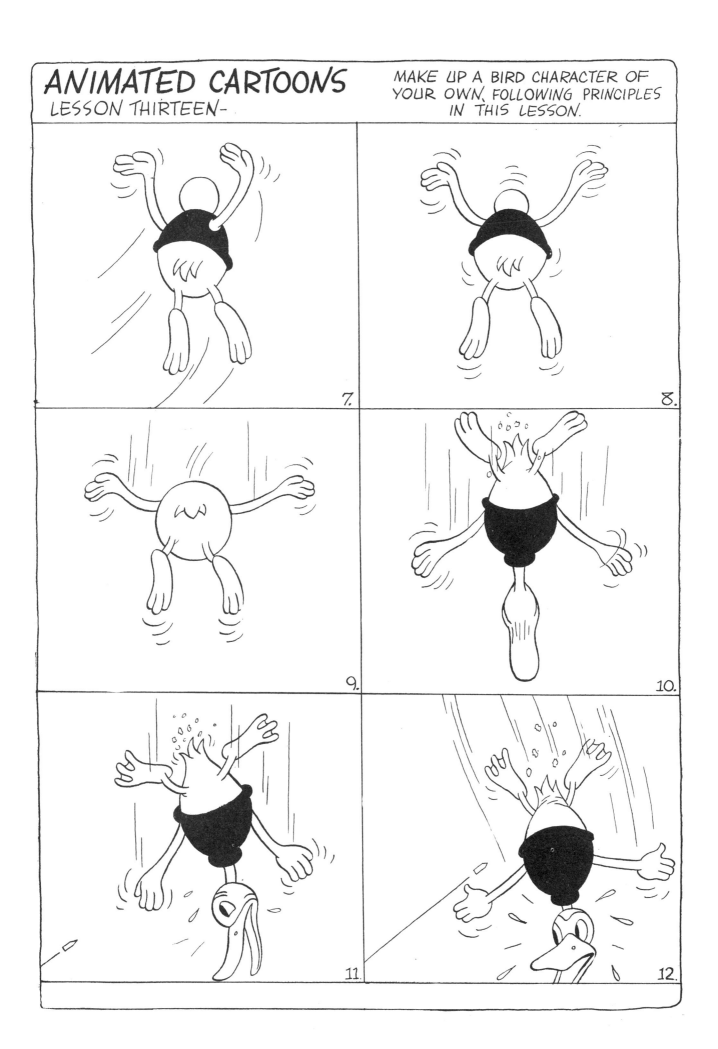

LESSON FOURTEEN ... ANIMATED CARTOONS

After the entire production is finished in these departments, the sound effect men and musicians go to work to "dub" in the sound. A metronome, which you remember, is that instrument with a short pendulum you used when practicing your piano lessons, is employed to judge the number of frames passing through the camera so that the music or sound will synchronize properly. Incidentally, the variety and volume of sounds emanating from one of these studios is not one for the book — it's something to write a book about. I think, however, that the main thing for anyone to remember in animated cartoons is best paraphrased by an old musical comedy — "Every little movement has a drawing all its own."

You can make an animated cartoon board of your own by just cutting in the center of your drawing board a hole 9" x 12" and putting in a piece of frosted glass held down by Scotch tape. Under this board place an electric light globe to enable you to trace the drawings. Using your animated cartoon board make a tracing of the duck shown on the opposite page. Place these in your left hand and riffle them with your right thumb and forefinger — study the action.

REVIEW QUESTIONS

1. About how much does each drawing of the duck move?
2. Do speed lines move an equal distance approximately?
3. How is sound applied to film?
4. What is the first move in making an animated cartoon?
*5. Name the most popular animated cartoon in your opinion that has yet been produced.

*See foreword

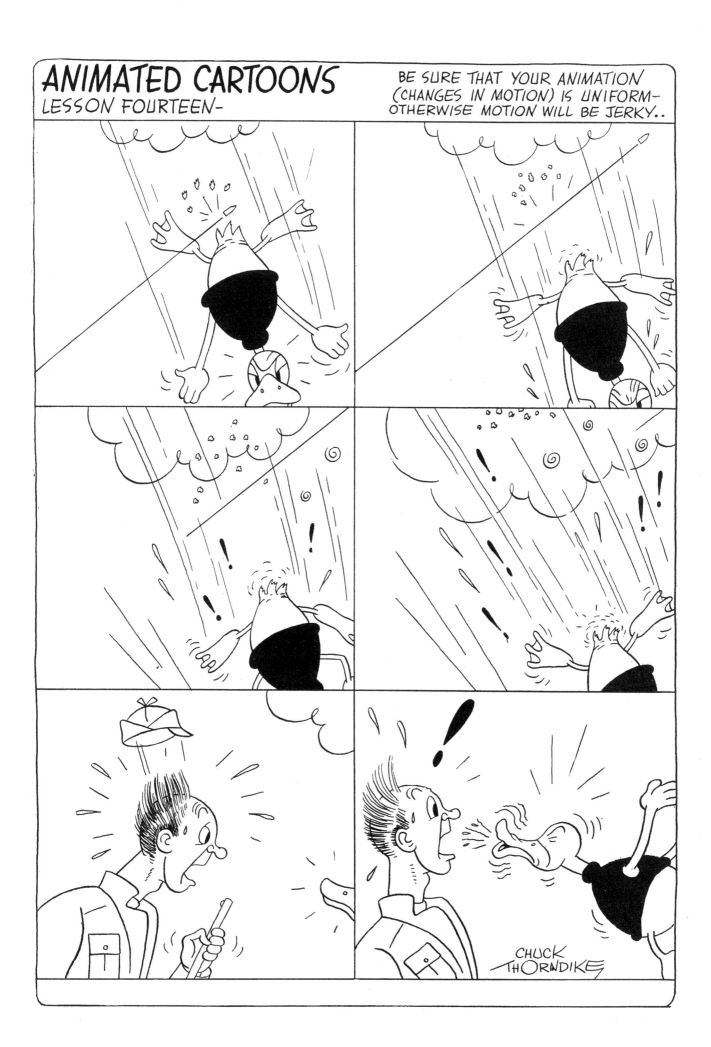

LESSON FIFTEEN ... POLITICAL CARTOONS

An editorial cartoon is a humorous illustration depicting a phase of the spot news of the day for a newspaper or magazine. This type of drawing is sometimes referred to as a "political" cartoon but, as the contents or subject matter is not always political, it is more generally called an editorial cartoon. This classification also varies from the so called "revolutionary" type of cartoon. To those of you who are familiar with some of the radical magazines and newspapers a differentiation between the two types will be easily apparent. The "revolutionary" cartoon pulls no punches, it usually portrays the personal feelings or opinions of radical editors.

The cartoons by Thomas Nast, America's first political cartoonist, and by Homer Davenport probably influenced public opinion to a greater extent than that of any other artist in our history.

An editorial cartoonist must be first of all an accomplished "humorous illustrator." Secondly, he must be familiar with the important timely and spot news of the day. Again he must be a rapid and concise worker. As lithographic crayon or pencil is used to a large extent in this work he should be familiar with this medium. He should also be familiar with all allegorical characters being used in this field and be able to create original ones of his own. Just as important as the draughtsmanship of this artist is his ability to GET IDEAS. If you have aspirations in this field I would suggest that you keep a catalogue file of the work of well-known editorial cartoonists and also pictures of the celebrities of the day. This latter material can usually be obtained at any library or newspaper morgue.

REVIEW QUESTIONS

1. Are editorial cartoons with one main figure generally more effective?
2. Does a syndicated editorial cartoonist have great freedom with his subject ideas or is he restricted?
*3. What artist drew the Pulitzer Prize editorial cartoon for 1928 and is this prize given every year?
4. Who was the first great editorial cartoonist in this country?
5. Must your ideas be timely?

*See foreword

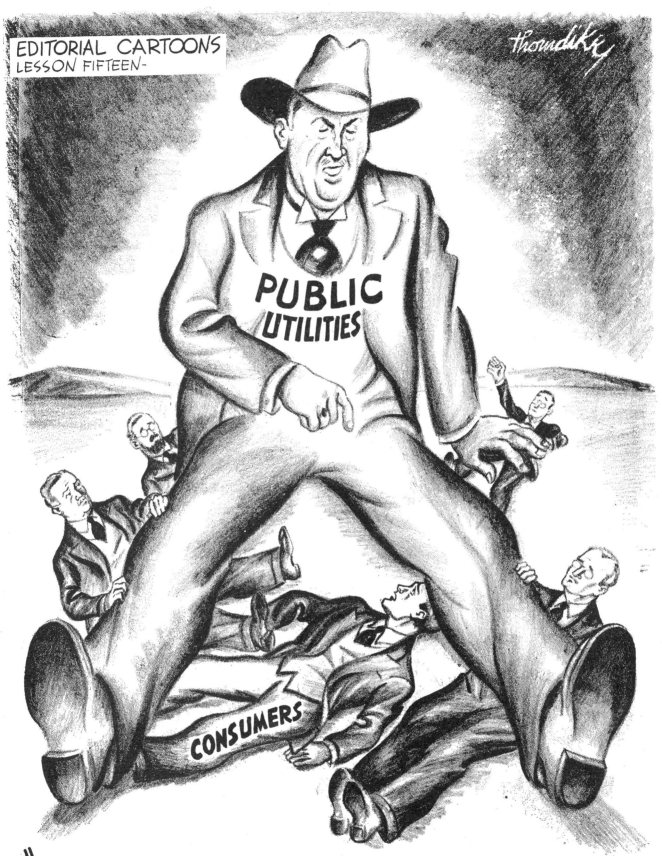

EDITORIAL CARTOONS
LESSON FIFTEEN—

PUBLIC
UTILITIES

CONSUMERS

"I GOT ORDERS TO SIT RIGHT ON YOU GUYS
UNTIL YOU SHOW SIGNS OF LIFE!"